Northwest Perspective Series
Tacoma Art Museum

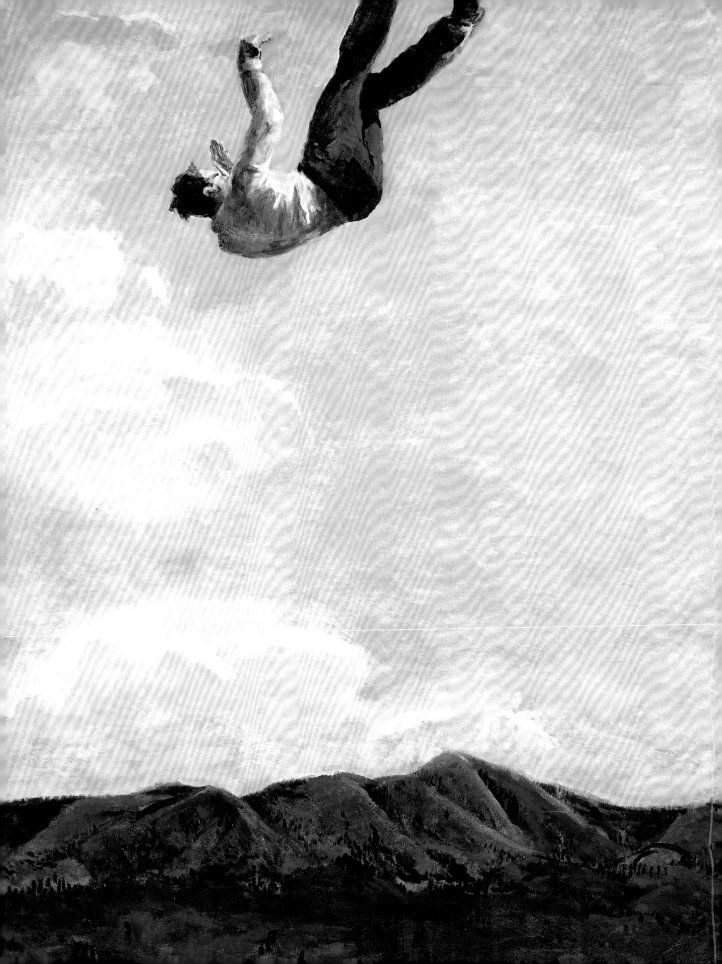

Rock Hushka

The Romantic Vision of
Michael Brophy

Contents

Directors' Foreword and Acknowledgments

Michael Brophy is a highly regarded landscape painter, equally committed to pictorial tradition and forceful storytelling. Through works that depict the savage beauty in the altered landscapes of the Northwest's rivers, forests, and mountains, Brophy carefully engages the social and political forces reshaping the national dialogues now defining environmental preservation and sustainability. Since the late 1980s, Brophy has created a remarkable and powerful body of work that is engaging, provocative, and bold.

The Hallie Ford Museum of Art and Tacoma Art Museum jointly present the exhibition and accompanying catalogue on this gifted artist. The collaboration came about naturally, as both our museums acknowledge the important contribution that artists who live nearby bring to our communities. Both museums are deeply committed to Northwest art and artists, building respective programs of exhibitions, collection development, and public interpretation around the regional art scene and its history. All too often, regional art does not receive the attention it richly deserves. Presenting the first museum exhibition on a strong painter like Michael Brophy and producing this monograph, *The Romantic Vision of Michael Brophy*, is one measure of our combined efforts to sustain the cultural vibrancy of the Northwest.

Our respective institutions are tremendously grateful to the artist, who gave his time and creative energies unsparingly to this project. Rock Hushka, Tacoma Art Museum Curator, has done a superb job working with Brophy to shape the exhibition and writing an insightful and authoritative essay. Laura Russo Gallery, Brophy's representative in Portland, Oregon, helped with the myriad details to make such an exhibition and catalogue a success. Marquand Books in Seattle, Washington, designed and produced this exquisite publication, for which we are deeply indebted. As is true of every loan exhibition, we extend thanks to the private and institutional lenders who agreed to part with their precious works of art. The Salem and Tacoma museum audiences are richer for the contributions of many to support the presentation of *The Romantic Vision of Michael Brophy*.

John Olbrantz
The Maribeth Collins Director
Hallie Ford Museum of Art,
 Willamette University

Rod A. Bigelow
Interim Executive Director
Tacoma Art Museum

Curator's Acknowledgments

An exhibition and catalogue project like *The Romantic Vision of Michael Brophy* begins the moment a curator first sees a painting by the artist. With each gallery and museum show, my admiration for Michael and his painting grew deeper. Since we began working on this project three years ago, I have come to know an extraordinary artist. I would like to thank Michael for his willingness to share his time and thoughts about art and history, environmental change, and the quirky qualities of life in the Northwest. I would also like to acknowledge his special brand of humor and let's-give-it-a-try attitude. Lastly, I would like to express my gratitude for his unwavering support of this project.

I am fortunate that Tacoma Art Museum and the Hallie Ford Museum of Art effortlessly agreed to collaborate on this project. John Olbrantz, director of the Hallie Ford Museum of Art, encouraged and developed this project in many important ways.

Professors John Findlay at the University of Washington, Doug Sackman at the University of Puget Sound, and Carl Abbott at Portland State University were crucial in clarifying some idiosyncratic ambiguities of Northwest history. The historians offered timely advice and generously shared their expertise. Ted and Sharlene Nelson also guided me through the complexities surrounding the politics of forest ecology. I would like to acknowledge Martha Lee at Laura Russo Gallery for her good cheer as she helped answer a myriad of highly detailed questions.

This essay was greatly improved through the efforts of editors Jana Stone and Sharon Rose Vonasch. Patricia McDonnell, Chief Curator at Tacoma Art Museum, deserves special mention for her challenge to approach this project in a sophisticated and scholarly manner. Without her expertise and guidance, this essay would be far poorer.

Ed Marquand and John Hubbard have my heartfelt gratitude. Their superb design and continuing generosity to Tacoma Art Museum are an inspiration to me.

In Portland, Ingolf Noto and Laura Russo provided constant encouragement. Without their support, this project would not have succeeded. Lastly, I wish to extend my sincerest thanks to the lenders to the exhibition. Through their generosity, Tacoma Art Museum and the Hallie Ford Museum of Art are able to share the scope and power of Michael Brophy's artistic vision.

Rock Hushka
Curator
Tacoma Art Museum

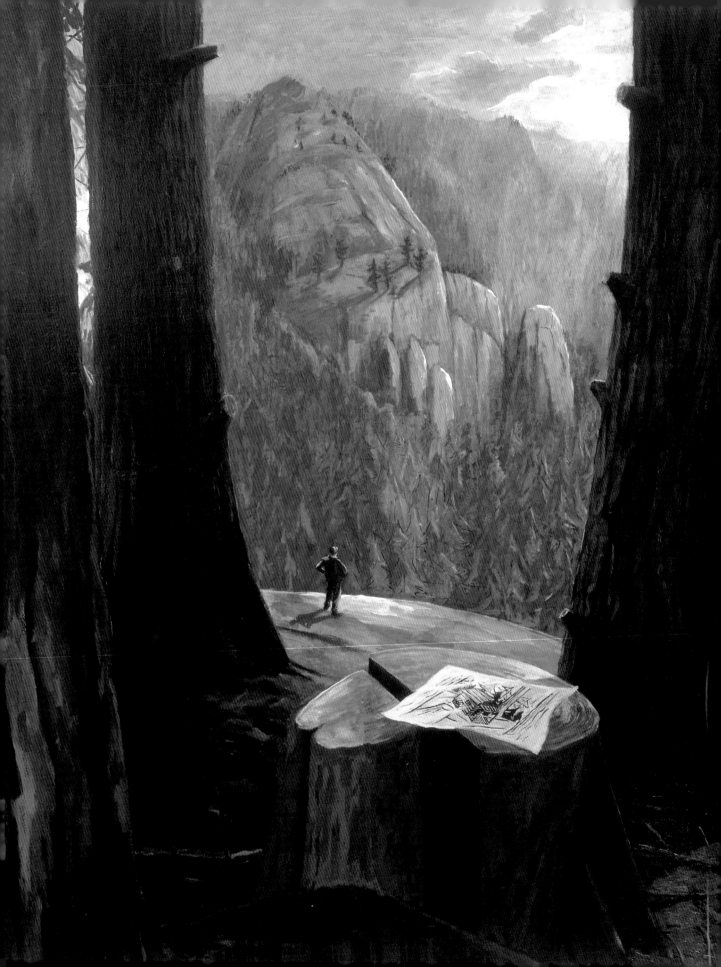

After Paul got the south side o' Mount
Hood all logged off, he hitched his Blue
Ox to his heavy plow, the one that'd turn
forty acre to two furrers, an' started in
breakin' it fer plantin'. But he didn't git
much done, fer Babe he stepped into a
yeller-jacket's nest an' ran away draggin'
the plow 'long. The gash he made in the
hills folks calls the Columbia River Gorge.

Ida Virginia Turney,
Paul Bunyan Comes West, 1928[1]

The "environment" is where we all live;
and "development" is what we all do in
attempting to improve our lot within that
abode. The two are inseparable.

Gro Harlem Brundtland,
*Our Common Future: The World
Commission on Environment and
Development*, 1987[2]

Did Michael Brophy Rig a Spar in the Sublime?

Painting the Intersections of History and Landscape

The startling contrasts between Ida Virginia Turney's folksy retelling of the legend of Paul Bunyan and Gro Harlem Brundtland's seminal report on environmental sustainability for the United Nations encapsulate the paradoxes confronting inhabitants of the American West. There are the mythic and grandiose histories that define a population of rugged pioneers who conquered the wilds of the Western landscape and reaped its bounty; there are also profound and ongoing changes to the landscape that prescribe the way Westerners live today and that will circumscribe the opportunities for future generations. In essence, the tension between the two perspectives reflects the way history leads into the future.

How the past and future shape daily life leaves many marks on the landscape. A road trip on Interstate 5 from Portland, Oregon, to Seattle, Washington, provides a virtual catalog of changes wrought by two centuries of Anglo-American settlement. Transportation grids crisscross the terrain: railroads, airports, and asphalt roads. Communication systems also overlay the landscape: mobile telephone towers, commercial radio and television towers, satellite dishes of various sizes, and telephone lines. Signage denotes shifting political boundaries: federal, state, county, municipal, and tribal. The economic infrastructure dominates the visual experience: downtown retail cores, suburban shopping malls, exurban strip malls, clusters of big box retailers, factory outlet malls, industrial parks, car dealerships, and fast food retailers. Many other sorts of development punctuate the journey between the two metropolises: military bases, colleges and universities, county fairgrounds, a defunct nuclear power plant, and a burgeoning Christian-themed sculpture park.

Yet despite the "development" or encroachment into once "pristine terrain," everything exists wholly within the bounds of nature. River systems still flow into the

Pacific Ocean. Mountains ring the horizon line, including the actively erupting volcano Mount St. Helens. Signs lead the way to ocean beaches, wilderness areas, state and federal parks, nature preserves, zoos, and special gardens. Each of these environmentally defined zones was created from innumerable decisions made concerning political, social, aesthetic, and biological issues.

The Portland-based landscape painter Michael Brophy (b. 1960) is one of the rare artists who explores how the multiple intersections of history and landscape shape the physical terrain. Not content merely to transcribe the contours of recognizable territory into paint, Michael Brophy believes the landscape is a stage for complex human interactions. Looking for traces of the rich history of Washington and Oregon in the contemporary, altered landscape, he paints the Northwest as sites on which great efforts and dreams emerged and dissolved. He eschews the sentiment and symbolism that inform the grand landscape tradition to concentrate, instead, on a deeper understanding of how people inhabit a particular place.

Through images that depict the brutal and savage beauty of the altered landscapes of the Pacific Northwest, he challenges the comfortable familiarity and mythic romanticism with which most residents of the Northwest view their home. Brophy wryly describes his work as making landscapes for his fellow urbanites. Because the majority of the population of the Northwest lives in the metropolitan areas of Portland, Oregon, and Seattle, Washington, Brophy's statement carries more than a tinge of irony.

His canvases depict the rivers, forests, and mountains that he and his fellow residents know primarily from frequent day trips or car camping excursions. However, in these paintings Brophy focuses not on our imagined, pristine Northwest landscape but on the human-created disruptions or scars that dot the actual terrain though are often deliberately ignored. Such subjects are rarely deemed worthy of art. They might seem temporary, or they are ingrained in the consciousness in such a deep way that they are taken for granted. They are avoided because they are so politically charged that it is not polite to discuss them in the company of strangers. He chooses to paint clear-cut hillsides rather than pristine forests. He prefers scenes of the slack water behind the Columbia River's hydroelectric dams instead of its mythical, mighty flow. He delights in the fact that Portland's skyline is barricaded and dwarfed by that city's West Hills. Portraying the flux of social and physical shifts, his landscapes remind us that countless decisions shape daily life, cultural values, and the physical terrain of the future of the region. His images of power transmission towers, flickering cityscapes, satiric historical characters, and tree stumps are so important because they signal ongoing changes to the landscape.

While exploring the aesthetic changes wrought by resource extraction and urban expansion, he also raises issues about the individual's moral and social accountability as they relate to the condition of the environment and its future. His paintings document the consequences of economic and political decisions made over the course of the last century and a half that continue to have a strong impact on how the landscape is used and is perceived.

The strength of Brophy's paintings can be ascribed to the fact that his images require engagement with multiple intellectual disciplines. When you look at a Brophy canvas, you see a landscape painting informed by the venerable traditions of the genre. You see his version of the scene's history. You see the environmental impact that reshaped the territory and think about how land functions as a place to work, as a place to live, or as a place for recreation. Lastly, you have an opportunity to ponder the philosophical foundations that shape our perceptions of the landscape and its meanings. In essence, Brophy works to help

us understand that the beautiful and cherished Northwest landscape is a real, dynamic place continually molded by an uninterrupted series of human interventions. It is a place of beauty and wonder, filled with stories of how people inhabit the territory.

The Romantic Vision of Michael Brophy outlines Brophy's efforts to create straightforward and thoughtful images of the Pacific Northwest at the turn of the twenty-first century. This essay considers the paintings of Michael Brophy as the synthesis of diverse approaches to the landscape in terms of artistic precedents, social and political histories, and the impact of emerging shifts in the environmental movement. Brophy's work as an artist can be read as a critique of the legacy of Manifest Destiny in the Pacific Northwest and the enduring consequences of fulfilling the American dream of economic expansion. These paintings question how history has been simplified by myth and legend while stressing the irony of the intended and unintended results of historic decisions that altered the landscape.

Brophy's painting divides into three general subjects: the forest ecosystem, the consequences of history, and the power of the Sublime. His images exist in the uncharted space between the tradition of landscape and history paintings. Blending historical research, photographic sources, and folktales, they ask two questions: "What does the Northwest look like?" and "Why does it look this way?" Sometimes humorous, other times sardonic or melancholic, his paintings offer a broad, myth-challenging view of the landscape as they articulate his response to the terrain as a product of human intervention.

Style and the Issue of Regionalism

Michael Brophy's painting style is well suited to the scope of his subject matter. Its hallmarks are the kind of bravura and confidence celebrated by most Westerners, present and past. With a nod toward the

idiosyncrasies of the Pacific Northwest, the distinct quirkiness of his style allows for the simultaneous recording of fact and depiction of grandiose mythologies. Like most Westerners, he has embraced this bifurcated view of the world and melds fact and fiction to generate his own personal viewpoints.

Brophy's solid, realist painting style is remarkably independent from his generation's preoccupations with abstraction and conceptual formats. His vigorous style references earlier, diverse sources: the WPA-era landscapes and figurative styles, early American modernism, and nineteenth-century romanticism. He evokes the grandeur of the nineteenth-century Hudson River school tradition by painting in a monumental scale. The extraordinary size of his work—*Key* measures 71 by 66 inches—engulfs the viewer (Fig. 1).

Within each painting, an astute viewer can understand how he creates pictures from a solid art historical background. Brophy employs formalism as a tool to construct sturdy and effective compositions in addition to the application of paint. His compression of the history of American painting results in a heady equilibrium of abstraction and realism. It is easy to see Brophy's pictures as representing actual places and filled with tangible objects. However, it is equally valid to notice that his images are fully abstracted.

His compositional structures are often indebted to the pure abstractions of the mid-twentieth-century abstract expressionists and the later color field painters. In a 1999 interview, Brophy declared: "You don't see it, but a lot of underlying structures in my work are actually based on abstract ideas, asymmetry and symmetry."[3] He tends to weight and balance his compositions equally from edge to edge and top to bottom. Each motif and each topographical feature play an equally significant role in his description of the scene. The proportion of the sky and horizon line is carefully calculated. His spatial arrangements suggest a vortex, swirling

FIGURE 1
Key, 1994
OIL ON CANVAS, 71 × 66 INCHES
COLLECTION OF THE ARTIST,
COURTESY OF LAURA RUSSO
GALLERY, PORTLAND

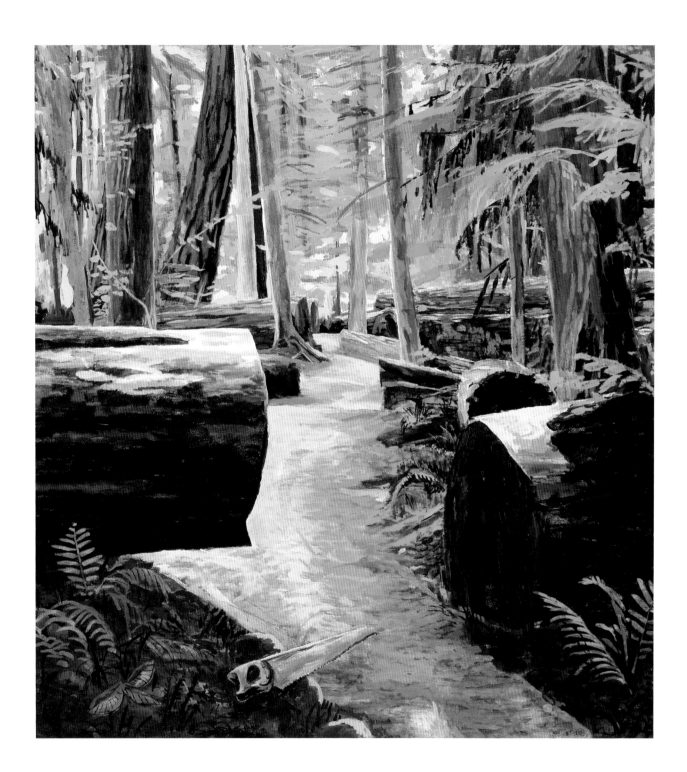

around and pulling the viewer's attention to the focal point.

In depicting individual objects and things, he has developed a representational system that harkens back to the flatness and geometries of the early American modernists, particularly Marsden Hartley (1877–1943) and Charles Burchfield (1893–1967).[4] His shapes, textures, and volumes are clearly descended from this earlier representational innovation. In this sense, Brophy is a "pure painter." He is not interested in a realistic depiction of the world but rather a reduction to simple forms. He makes paintings, not illusions. By reducing the illusion to two-dimensional imagery, Brophy emphasizes his role as arbitrator between the actual world and the realm of concepts.

It is also crucial to understand Brophy's urge to simplify his forms as a mastery of "pure painting." He learned to paint well, and he revels in the tradition of the painter's craft. He paints honestly. He refuses to develop gimmicks or employ shortcuts. He carefully lays down distinct brushstrokes that are masterfully arranged to delineate his imagery. He uses a fully loaded brush, but he paints economically rather than slathering and drowning his canvas with pigments. Using a jewellike palette of blues, greens, browns, and blacks, Brophy's landscapes celebrate the moisture-laden atmosphere of the Cascade Mountains and the rich, earthly sensuality of the Northwest forests. He fills his canvases with a sparkling light that animates the land and its inhabitants.

Brophy remains keenly aware of his hand by the direction and size of the tiny ridges left by each touch of his brush on the canvas. In many of Brophy's paintings, such as *January*, distant trees, figures, hillsides, and skies are actually an irregular terrain of paint clumps (Fig. 2). He always scumbles. Impasto activates and electrifies the surface of the canvas. He applies layers of glazes to deepen shadows and to shape contours.

Perhaps the most surprising aspect of Brophy's painting is how thin his paintings are. All of his layers amount to something of a minute fraction of an inch thick, a technique that he has continued to hone. As he has developed and refined his abilities, the paintings continue to become thinner but no sparer or less sensuous for his refinements. Nonetheless, his economy with paint is circumscribed by his need for the brush to flow easily. The sense of flow is critical to understanding Brophy's purpose as an artist. He thinks as he paints. Pushing and pulling the globs of wet paint across a slightly textured canvas transforms his thoughts into material objects. This action preserves Brophy's intellectual insights, his beliefs, his observations, and his emotional reactions.

Brophy's learned approach to painting was encouraged by his work at Pacific Northwest College of Art (PNCA) in Portland. He earned his bachelor's degree of fine arts from PNCA in 1985 and frequently teaches painting at the school as an affiliated faculty member. His instructors and mentors included Henk Pander and Lucinda Parker, both eminent and respected Portland artists. As a student at PNCA, Brophy and his student colleagues revered Pander as the senior figure in the Oregon art scene. The students early sought out Pander's images and discussed them at length. Pander's work is appreciated for its vigorous realism and technical proficiency. Brophy knew Parker as a senior faculty member at PNCA. Parker creates painstakingly constructed abstractions that explore linguistic play.

Brophy has benefited in a variety of ways from the historical relationship between PNCA and the Portland Art Museum. PNCA was founded in 1909 as the Museum Art School for the Portland Art Museum. The Museum Art School changed its name to Pacific Northwest College of Art in 1981, and, a decade later, PNCA formed its own board of governors and began to separate itself institutionally from the Portland Art

FIGURE 2
January, 1997
(DETAIL, SEE FIG. 13)

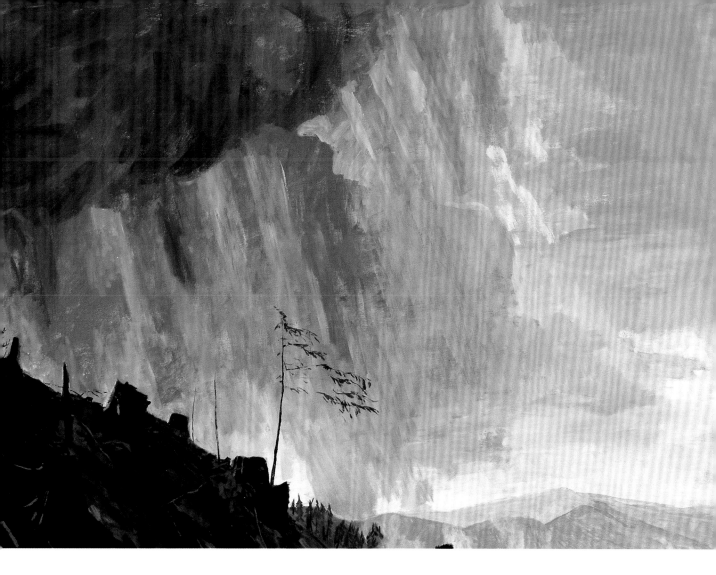

Museum. It became an autonomous educational corporation in 1994. Throughout the nearly ninety-five years of mutual existence, the Museum School and the Portland Art Museum brought the highest level of modern art to Portland and the Northwest. Works by Childe Hassam (1859–1935), Albert Pinkham Ryder (1847–1917), and J. Alden Weir (1852–1919) graced the galleries in turn during the early decades (the museum, founded in 1892, is the oldest of Northwest art institutions). Marcel Duchamp's (1887–1968) *Nude Descending a Staircase* was shown in Portland after the Armory Show in 1913. European and American modernism was often seen at the museum before 1950: Pablo Picasso (1881–1973), Henri Matisse (1869–1954), André Derain (1880–1954), Maurice Prendergast (1859–1924), Preston Dickenson (1891–1930), Constantin Brancusi (1876–1957), and the German group of early twentieth-century modernists *Der Blaue Reiter*.[5]

As a child and later as an art student, he walked through the museum and absorbed the visuals of important works of European and American romantic and modern art. An alumnus of PNCA, Brophy is the heir to a distinguished intellectual and aesthetic tradition in which artists were expected to engage, to synthesize, and to move beyond established modernist tenets. He learned to think about painting independently while always striving to improve his

work through a discipline grounded in an academic tradition.

The relationship between his thinking patterns and painting process is important especially when one considers the scale of his paintings. Brophy most often paints on a grand scale. His canvases average in size just over six feet square. In crude statistical terms, the large-scale imagery requires him to cover and recover 36 square feet with a brush that is less than a quarter-inch wide. This lopsided proportion should be understood as a metaphor for the tendency to feel dwarfed when immersed in the Northwest terrain. From the earliest explorers and the first settlers in the nineteenth century to today's day hikers, physical exertion is a way to know the place, to feel it literally in the bones and muscles. This sense of labor connects Brophy more closely to his subject matter, like his ancestors and the historical characters.

The size of the canvases also directly relates to Brophy's own personal experience. Brophy credits his grand scale efforts to his physical size. Because he stands six feet three inches tall, the monumental canvases capture the sweep of his peripheral vision. This painting is what Brophy himself sees, and, perhaps not coincidentally, it is also the reach of his extended arm as he holds the paintbrush. The paintings become a material manifestation of how Brophy exists—physically, intellectually, and emotionally—in the Northwest landscape.

In experiential terms, the paintings engulf the painter and viewer. They portray vistas or tableaux that allow a virtual experience within a scene on a human dimension. In many works, his grand canvases purposefully set the scale and perspective of a person standing in the forest or on the ridge above the Columbia River. Brophy plays with scale to evoke physiological responses akin to those experienced at the scenic overlooks or at the trailheads. Although this simulacrum underscores the artificiality of the scene, it is this constructed perspective that most interests Brophy.

Because Brophy was raised in Portland and continues to work there and because his subject matter is so specific to this region, he is often labeled as the quintessential painter of the Northwest. This categorization raises the specter of regionalism.[6] Is he a regionalist painter? This question can be answered honestly in both the affirmative and the negative. The short answer "no" must be given because Brophy's complex approach to the act of painting and his critical look at the landscape defy the boundaries of the Northwest. Brophy is thinking and responding to environmental and cultural issues in ways parallel to historians, environmental advocates, artists, and sociologists working in every region in the United States.[7] The answer "yes" must also be equally posited. Without his personal connection to the region and its cultural traditions, Brophy's paintings would lack their passion and strength. There would be virtually no context for them, and they could be read only as an isolated artist's musing about some random, faraway place awash in the tide of history.

Brophy's bond with the physical places of the region is a crucial aspect to his painting. It is also a hallmark of regional identity in general. Historian Richard White emphasized this reflexive relationship between a place and its inhabitants: "Human beings created landscapes, and these landscapes in turn have consequences for the society which created them."[8] The heart of his perspective stems from Brophy's personal history. He was born and raised in Portland, his family lives in western Oregon, and he continues to rely on the landscape for sustenance. The weather is temperate, and the choice for recreation always offers a pleasant conundrum of two extremes. Do you take advantage of the cultural life of the major metropolitan areas or explore the rugged coast, the mountains, or the desert? The scenes of his paintings reflect such a bountiful dilemma of places and choices readily accessible in the Northwest.

He stages his paintings with the skyscrapers, the freeways, the rivers, the forests, and the canyons that he knows intimately.

Furthermore, Brophy's sense of allegiance to his native region has been honed by his reading. In addition to immersing himself in the place, he has sought to understand how other people convey their connection with the region. He has found two distinct lines of thought on the subject. His studio bookshelves contain, among the art books, more than a decade's accumulation of the *Oregon Historical Quarterly*. These back issues provide a formal, scholarly examination of historical facts and subjects. Building on the work of these scholars, Brophy seeks to clarify the contradictions and ambiguities of the region's history. A second line of thought involves those historians who celebrate the personalities and linear progress of historical events. This line of inquiry often becomes a celebration of the mythic aspects of the legends that define the Northwest character.

Early Portland: Stump-Town Triumphant: Rival Townsites on the Willamette, 1831–1854, one of Brophy's favorite histories of early Portland, gives a flavor of the humor and personal engagement with which Brophy looks at the territory and its history. Written by the independent historian Eugene E. Snyder, this book traces the failures and successes of the early personalities as they sought their fortune in the area that is today's metropolitan Portland.[9] Brophy's fascination with this text lies in Snyder's focus on the immigrant founders of Portland in a virtual hagiography of these heroic, romanticized, rough-and-tumble entrepreneurs. Brophy revels in Snyder's mythmaking and the exclusion of any fact that introduces an ambiguous element in the narrative. In his introduction, Snyder reveals his sincere personal connection to the men of the distant past: "As I learned the details of the lives and endeavors of those early townsite proprietors, they began to seem like contemporary friends. Their characters came vividly through the years, because they were 'Personalities,' and rugged ones, each a pillar of individualism. Familiarity did not breed contempt. On the contrary, closer acquaintance added affection to respect for those pioneers."[10]

Brophy finds gentle humor in such one-sided histories and uses texts like *Stump-Town Triumphant* to draw attention to the ironies of history. He looks to these stories as a place to explore the fractures separating hero-trumpeting narratives that emphasize personal accomplishments and histories that offer a fuller, more complex account of events. The incongruities between the mythical past and a more comprehensive understanding of the region's various and more textured histories fuel Brophy's passion.

Another significant influence on Brophy's thinking about native regionalism and its impact on his painting is the volume of essays presented and discussed at the Writers' Conference on the Northwest, which was held at Reed College in Portland in the autumn of 1946. The collected papers and commentary were published as *Northwest Harvest: A Regional Stocktaking*.[11] The writers invited to participate were asked to discuss their perception of the Northwest as a place distinct from the rest of the country.

Brophy jocularly refers to the contributors to *Northwest Harvest* as "Holbrook and the gang." His humor underscores his familiarity with their theses and hints at his satisfaction with how he relates to their ideas and observations. When asked to explain more about his attraction to this obscure collection of essays, Brophy becomes almost reverential. The participants, with their distinguished careers and multilayered contributions to the region's cultural identity, provide Brophy with a constant reaffirmation of his goals. It is almost as though this particular book allows Brophy to continue on his chosen agenda by linking him to key intellectual predecessors.

In 1946, the writers looked hard within themselves and at their neighbors to find the traits, things, and ideas that defined the Northwest as distinct from any other region within the United States. In his opening remarks, Peter H. Odegard urged his audience down a now-familiar path: "We need to discover in our own cultural heritage and to encourage our own youth to look about in their own back yard to find inspiration and employment for their creative talents."[12] Odegard's emphasis on a regional focus is somewhat unexpected. His background includes a doctorate from Columbia University in New York City; appointments at Columbia, Williams College, Ohio State, Stanford, and Amherst; and service as a staff member for the secretary of the treasury during World War II.[13] His comments cannot be seen as a myopic celebration of the hometown but rather as one step of defining the Northwest in relation to only its inhabitants, its culture, and its geographic particulars. This kind of self-examination would allow the Northwest to be a distinct yet integral part of the larger vision of the national whole.

Brophy's paintings suggest that he also seriously applies this exact brand of introspection. It is evident in his landscapes and his history paintings. Consider his solitary figures standing in the landscape, one of Brophy's most highly honed motifs, in paintings such as *Measure* (Fig. 3). What kind of person is this? What does he see? What does he think? The man is likely Brophy himself, but he is also without a doubt a surrogate for the prototypical inhabitant of the Northwest. He could be one of the high-tech billionaires, a barista, a farmer, a teacher, a doctor, a truck driver, or a construction worker on a day hike.

At the Writers' Conference, Ernest Haycox offered a list of defining characteristics of the Northwesterner: The average "northwest man" is a more open and optimistic animal than his "eastern" brother; he has a strong sense of personal autonomy; he does not harbor any class consciousness, yet constantly seeks opportunities; he is politically conservative, yet pioneering in his thinking; his livelihood depends on resource extraction; he is not boisterous or a bawdy extrovert; he avoids excess and shies away from the intemperate act or word. In general, he is prone to understatement rather than overemphasis.[14] Brophy's solitary figure cannot be anyone other than Haycox's prototypical Northwesterner: an individual in a forest, clothed in much-loved hiking gear, silently contemplating the remains of a long-ago past.

Modeling a description of Brophy from Haycox's observations is virtually irresistible: a painter who developed a quirky, rugged, and powerful painting style to capture the power of the Northwest landscape, expressing both melancholy and celebration at the changes wrought since the arrival of the first European explorers in the eighteenth century and Lewis and Clark's Corps of Discovery in the early nineteenth century. How well Brophy fits within the mold of the Northwesterner is further strengthened by a more recent, scholarly examination of the issue of regionalism. Richard Maxwell Brown looked specifically at those issues defining the Northwest in 1983. In his essay "New Regionalism in America," Brown described how Northwesterners sought to identify themselves: "The three predominant themes of West and Pacific Northwest regionalism of the 1970s and 1980s are (1) the individual quest for identity in terms of the region, (2) the symbiosis of art, architecture, literature, and history with the natural environment, and (3) the tension between the classic and the counter-classic in western history and culture."[15] These are the same concerns that the writers expressed half a century ago but updated to fit more comfortably into the social and political situation of the early 1980s.

Not surprisingly, Brophy fits well within Brown's paradigm as easily as he does Haycox's. Brophy shares Brown's emphasis

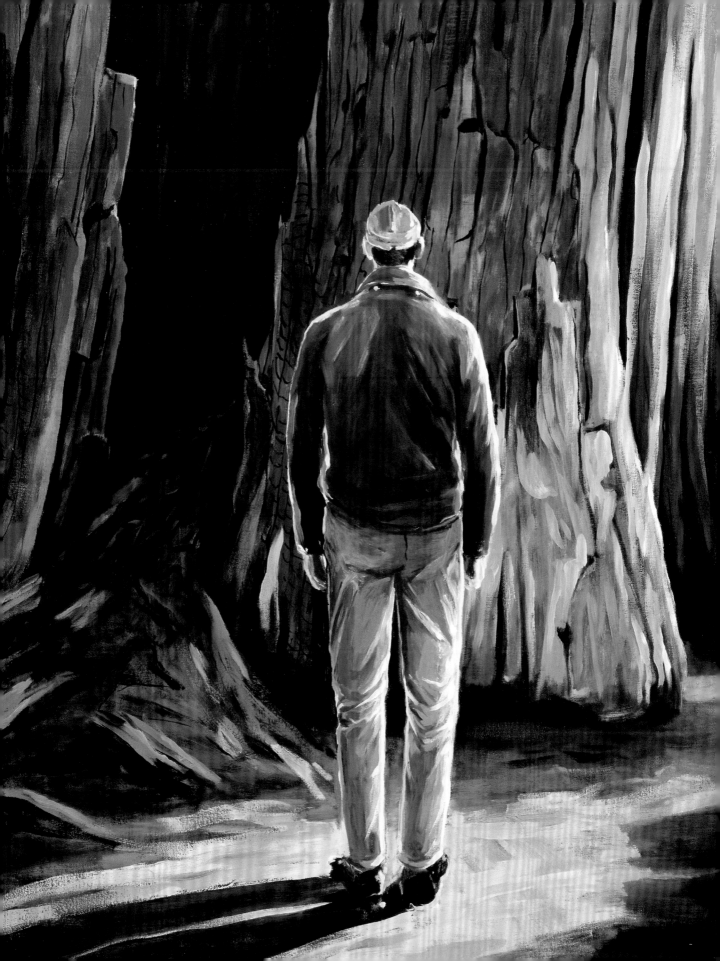

on the "symbiosis of art, architecture, literature, and history with the natural environment." This conceptual development is part and parcel of its time, an indication that people are looking to shape their future through a thorough grasp of their past. Brophy's thinking is a synthesis of historic legends and scholarly histories. His conclusions lean toward a newer thinking about the landscape and its history, finding sly humor and irony in the way we present ourselves.

Brophy is one of the few artists who has successfully united two diametrically opposed positions: he manages to address strictly regional concerns of subject matter; yet, he is also able to transcend the restrictive aspects of the label "regionalist" and create works that speak about larger concerns—those that shape life in the American West and thus play a role in reshaping the national sense of identity.

In strictly art historical terms, Brophy joins a sweeping list of artists whose work underscores the relationship between artistic production and cultural issues. Even so, he has carved out a unique position as an artist in capturing the sense of regional identity of a place. He avoids the nostalgic yearning that was the hallmark of the nineteenth-century painters of the American scene. He lacks the wistfulness of George Caleb Bingham's (1811–79) trappers gliding down a placid Missouri River on a flatboat. He refuses the tender sentiment that fills the images of old Puritans and cranberry harvesters popularized by Eastman Johnson (1824–1906). He shuns the caustic commentary that pushed American scene artists like Jack Levine (b. 1915) and Mabel Dwight (1876–1955) to prominence in the Depression era. He tempers the boosterism of American scene painters of the mid-twentieth century like Grant Wood (1892–1942) or Thomas Hart Benton (1889–1975).[16] Like these artists, Brophy is very much responding to the current political and social uneasiness. His paintings reflect the difficulties facing the people of the Northwest as the region continues to develop. These difficulties are accented by the conflation of a mythological past and celebration of the endless resources of the region with the harsher, less glorious realities of limited resources and development concentrated in cities and suburbs.[17]

The subtext of Brophy's painting is that solely glorifying the past will not help build a sustainable future. His scenes smartly depict what he sees and open a dialogue on how this region has been shaped and recast. His purpose is not to look romantically backward and yearn for a lost or disappearing culture. He shakes off those self-aggrandizing myths to prepare for the future.

The Forest Ecosystem

The forest ecosystem is virtually synonymous with the Northwest. Seemingly endless stands of evergreen trees (primarily Western hemlock, Western red cedar, and Douglas fir) blanket the territory on the western slopes of the Cascade Mountain range. From the time of first human inhabitation, the forests have dominated every aspect of life. Ancient legends about the forest and its inhabitants from the many different indigenous Native American cultures still permeate the Northwest.[18] Comparatively, Anglo-American experience with these forests is a mere two centuries old. First, the English and Spanish explorers used the massive timber to replace riggings on their ships in the late eighteenth century. In the mid-nineteenth century, the region's timber was exported to the burgeoning cities of San Francisco and Los Angeles. With the completion of the transcontinental railroad later in the century, Eastern markets gained easy access to a seemingly endless supply of high-quality and very inexpensive Pacific Northwest timber. The great wars of the twentieth century and their subsequent postwar economic booms were made possible in part by the unending stream of wood products from the Northwest forests, and

rapidly improving technologies made harvest more efficient and created innovative new products such as plywood.[19]

The economic prosperity, however halting, that was sustained by the extraction of timber resources formed the bedrock of the history and development of the region. The metropolitan areas of Vancouver, British Columbia; Seattle; and Portland were quickly carved out of ancient forests. Additionally, the inhabitants of the urban, the suburban, and the increasingly important exurban areas continue to rely on the forests for economic development and shelter. The millions of inhabitants of the area also use the vast acreage of protected forestland for recreation purposes and spiritual renewal and as a touchstone for self-identity.

Brophy searches for the ruptures between idealized preconceptions of the landscape and its actual state. The critic Randy Gragg concisely stated this as "a simple conflict between powerful illusions."[20] Brophy counters the deeply ingrained idea of wilderness—a placid, endless, and wild terrain. He refuses to separate human beings from their place in the environment.

It is crucial to emphasize that humans have shaped the American landscape from the first instance of permanent settlement. Humankind has reshaped the land of North and South America beginning thousands of years before European contact.[21] The scope of this can be grasped by recalling the existing remains left by pre-Columbian civilizations of Central and South America, the mound-building cultures of the Midwest, and the pueblo dwellers of the Southwest.

From the arrival of Europeans, perceptions of the land and beliefs about how the landscape should function developed from the confluence of nation-building, religious faith, and the search for an artistic identity. When the first Puritans settled the New World, they did so with the hope of creating a New Jerusalem in the wilderness. For these new settlers, the mere existence of an "unpopulated" land—meaning solely that there were no existing populations of other Christians to argue about God and godliness—was proof of a Divine desire to have a pure and unsullied civilization on earth. The "empty and unsettled" land became a place to establish a godly society. This landscape was seen as a gift from God to his chosen people and as a place of uncivilized terror, where life itself could be extinguished by the forces of nature. Out of this ideological and philosophical ground developed the line of thought of the American transcendentalists, who sought to unite all mankind, Nature, and God. Nature, and through it, the land, thus became an allegorical crucible for the relationship between God and humans.[22]

By the mid-nineteenth century, this deeply religious response to nature had been absorbed into the American consciousness and subsumed into a different perception of the landscape. The first was that the land was a source of endless bounty, and a literal garden could be cultivated in the wilderness.[23] This belief led to the ideal of a yeoman farmer as the foundation of the new United States championed by President Thomas Jefferson. Secondly, the untamed and "unsettled" territory was seen as a distinctly national treasure. Painters and writers found the scale and variety of the landscape to be a suitable counterpoint for the artistic traditions of Europe.[24]

In 1835, Thomas Cole (1801–48), the first prominent American landscape artist, reflected on the vast unknown American terrain and its relationship to God and art. "All nature here is new to art," Cole wrote, "No Tivoli's[,] Terni's, Mont Blanc's, Plinlimmons, hackneyed & worn by the daily pencils of hundreds; but primeval forests, virgin lakes and waterfalls feast his eye with new delights, fill his portfolio with their features of beauty & magnificence and hallowed to his soul because they had been preserved untouched from the time of creation for his heaven-favoured pencil."[25] Cole also sought an allegory for spiritual

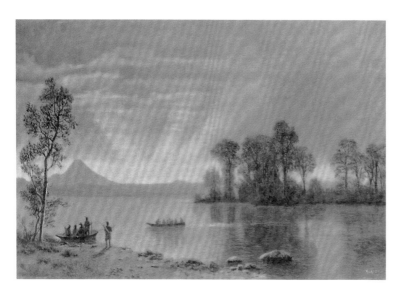

FIGURE 4
William Kurtz,
Mount Hood, Oregon
[after Albert Bierstadt],
1889
PHOTOENGRAVING, 4⅞ × 7⅛ INCHES
NATIONAL GALLERY OF ART LIBRARY,
GIFT OF JOSEPH WIDENER

FIGURE 5
Michael Brophy, *Couple*, 1995
OIL ON CANVAS, 65 × 70 INCHES
COLLECTION OF THE ARTIST,
COURTESY OF LAURA RUSSO
GALLERY, PORTLAND

redemption based on the emotion and religious awe inspired by the relentless and unknown forces of nature. Some of Cole's titles, such as *Tornado in the Wilderness* and *The Voyage of Life*, hint at the fascination of this synthesis.

By the time of Cole's death in 1848, the mainstream of American landscape painting focused primarily on the underdeveloped territory as a symbol of future prosperity and nationalism. Many of these scenes depicted an isolated, bucolic homestead, perhaps as a salve against the rising anxieties before the Civil War. By the late nineteenth century, the focus turned to the celebration of the extraordinary natural features of the Western landscape and the technologies that would extract value from those features. For example, Thomas Moran (1837–1926) achieved celebrity for his scenes of the color and geological oddities of the Yellowstone region, and Albert Bierstadt (1830–1902) painted the Rocky Mountains and Yosemite Valley, expressing a hyperbolic excess bordering on the unreal. The drama of these late-nineteenth-century paintings can be seen in the photoengraving by William Kurtz (1833–1904) after a painting of Oregon's Mount Hood by Bierstadt (Fig. 4). The exaggerated form of the mountain, the placid lake in the foreground, and the framing devices of the trees at the left and right margins reveal an interest weighted in formal compositional devices and emotional impact rather than in verisimilitude or a desire to provide an accurate rendering of an actual place.

Brophy activates this tradition, but he redirects it from the grand overview to focus on the experiential. In the early painting *Couple*, the two trees that seemingly twist toward one another on the crest of a mountain ridge share an uninterrupted tranquility in the woods (Fig. 5). The broken and fallen branches, the ferns under the trees, and the distant peak across the valley emphasize the untamed and disorderly aspects of the scene, which could be experienced on a

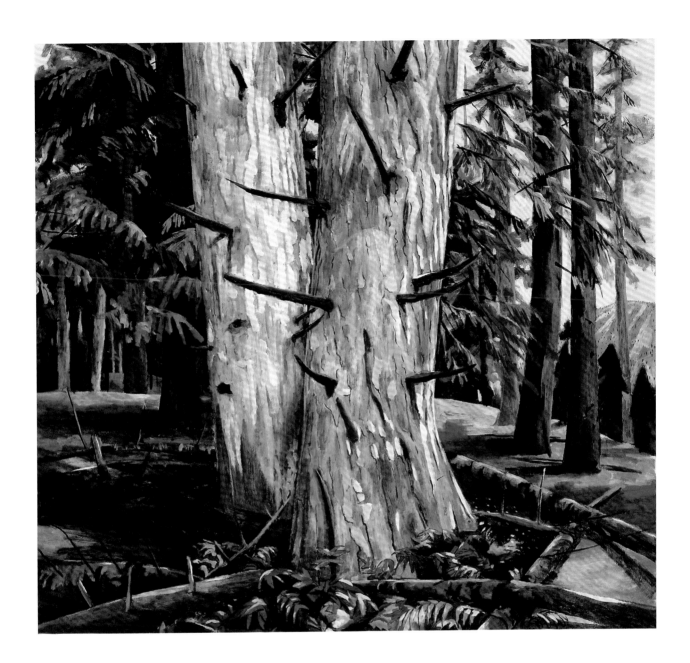

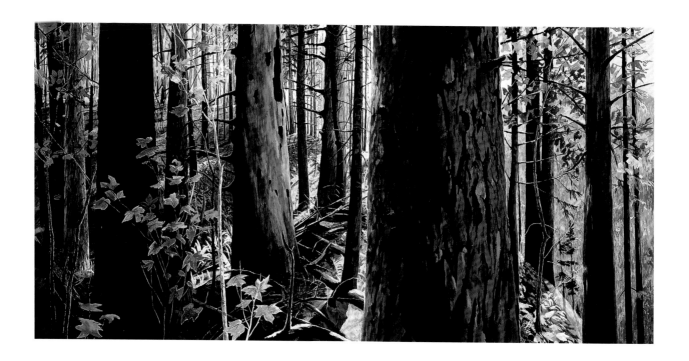

FIGURE 6.1

Gorge Forest #1, 1997
OIL ON CANVAS, 84 × 168 INCHES
COLUMBIA GORGE DISCOVERY
CENTER AND MUSEUM,
THE DALLES, OREGON

day hike in any of the forest preserves. This simple, logical observation comes after a direct personal experience and reflection about the scene. Radically different than Bierstadt's *Mount Hood*, it is a celebration of a mundane discovery, not an apotheosis of an extreme geological formation.

For a major commission at the Columbia Gorge Discovery Center and Museum at The Dalles, Oregon, Brophy offered a version of the forest that distills the essence of our society's preconceptions of a forest (Fig. 6.1–2). He evoked the stillness created by the moist, decaying forest floor by rendering the forest as tree trunks and ferns darkly colored in deep browns, blacks, and greens. The absence of any trace of a human presence offers a vision of an undisturbed forest, and the sliver of the Columbia River seemingly guards the forest from any potential intrusion. Because it looks and feels so natural, the virtual impossibility of such an idealized forest is completely lost. This is not a dynamic, living ecosystem. It is a symbolic one.

Brophy pushes this idealization of the forest into the realm of abstraction with paintings of snags (Figs. 7, 8, 9). A snag is the standing remains of a tree (usually killed by natural forces such as fire, insect infestation, or lightning). Snags play an indispensable role in healthy forest ecosystems. Because the outer wood remains rigid while the interior decays, snags provide crucial habitat for birds, insects, small mammals, and microscopic life. Without snags, the natural life cycles in the forest cannot function.[26]

The inspiration for this series of paintings is a particular snag that stands near Highway 26, about forty miles west of Portland. The size alone captured Brophy's attention—the snag is at least six feet in diameter and fifteen feet tall. The giant inspired him to think about its history. The tree lived much longer than a century and bears the telltale notch that shows it was cut for timber. The snag survived the repeated fires of the Tillamook Burn of the 1930s and 1940s.[27] It stood throughout decades of reforestation and was left alone during the recent harvest of the subsequent second-growth forest.

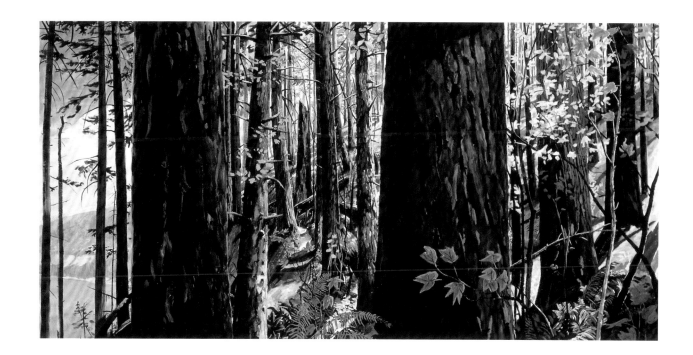

FIGURE 6.2

Gorge Forest #2, 1997

OIL ON CANVAS, 84 × 168 INCHES
COLUMBIA GORGE DISCOVERY
CENTER AND MUSEUM,
THE DALLES, OREGON

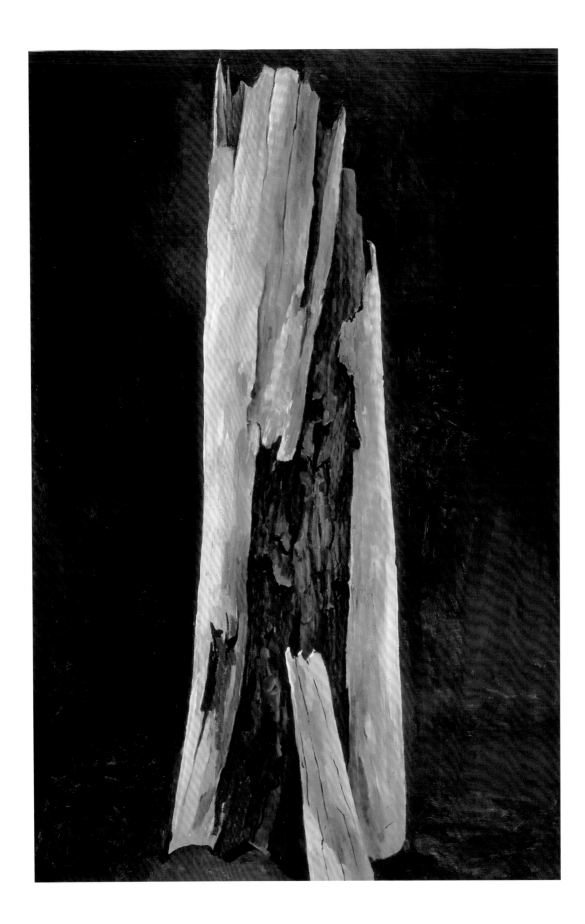

FIGURE 7
Snag I, 1997
OIL ON CANVAS, 91 × 60 INCHES
TACOMA ART MUSEUM, GIFT OF THE
ARTIST AND LAURA RUSSO GALLERY,
PORTLAND

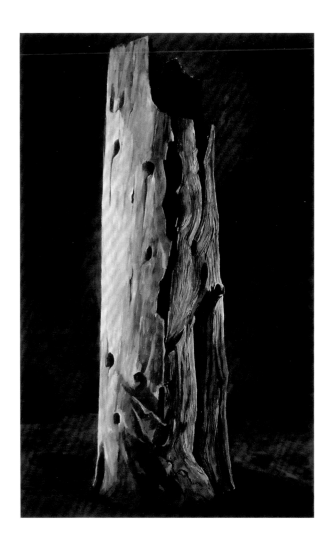

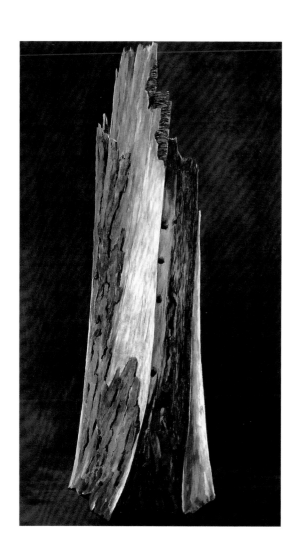

FIGURE 8
Portrait, 1997
OIL ON CANVAS, 96 × 60 INCHES
PRIVATE COLLECTION

FIGURE 9
Snag II, 1998
OIL ON CANVAS, 95 × 54 INCHES
COLLECTION OF ARLENE AND
HAROLD SCHNITZER

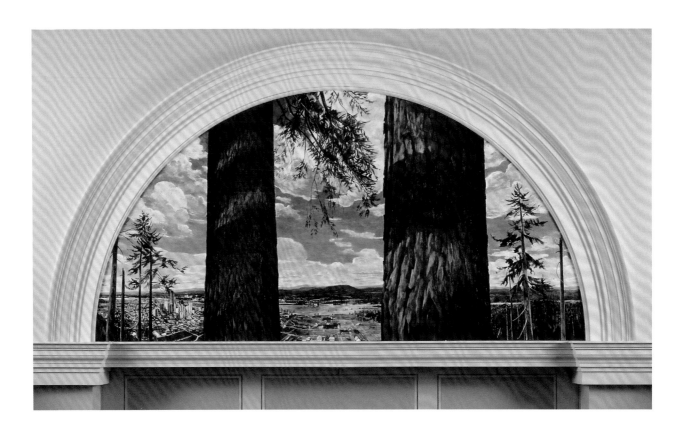

FIGURE 10

*Lower Willamette Arch:
River and Forest*, 1998
OIL ON CANVAS, 48 × 96 INCHES
THIS ARTWORK IS INSTALLED AT
PORTLAND CITY HALL UNDER THE
CITY PERCENT FOR ART PROGRAM,
ADMINISTERED BY THE REGIONAL
ARTS AND CULTURE COUNCIL,
PORTLAND, OREGON

Because the snag withstood the ravages of both man and nature, Brophy thought it deserved reverence for its role in the forest's history. Using the convention of formal portraiture, Brophy isolates the enormous snag. The deep background with a dappled light playing across the darkness centers the attention on the "sitter." It is an anthropomorphic conceit. He invests this inanimate object with the human qualities of dignity, stature, and respect. Such a portrait symbolically preserves its most enduring features for posterity. With these portraits, Brophy relates the social functions of portraiture to parallel issues concerning the long-term management of forests. Because snags are crucial to a healthy ecosystem, they must be allowed to function within the natural order and must be included as an inseparable part of the forest's existence.

Many of Brophy's other paintings also spring from the idea of a perfect forest and push into more complex territory. With the mural *Lower Willamette Arch: River and Forest*, commissioned for the City Hall Council Chamber in Portland, Brophy uses the notion of a forest as a scrim separating past from present, reality from idealism (Fig. 10). He uses the collective memory of forested spaces to evoke the very foundation of Portland, which was carved from the forest and made rich from timber. This source is the first thing you see in the painting, a narrow, isolated swath of the forest. Each section of the mural offers a low-key reminder that the forest dominated the early decades of the city. The right section shows only a path through the river bottom, the central reveals a modest settlement, and the left shows a glimpse of the contemporary cityscape. Although the tree trunks dominate the murals, the space beyond the trees is the actual subject—the area above the urban core of present-day Portland as seen from the West Hills.

This space is filled with a sharp, white light that envelops the city of Portland. Brophy describes this light as piercing and

brittle and bleached-out, analogous to an overexposed, vintage photograph. This brilliant light is one of the keys to Brophy's painting. He uses it in virtually all of his daytime scenes. Because it is based upon a natural phenomenon that he experiences daily, it permeates his approach to the terrain. It functions as a kind of extended metaphor. Brophy has observed that the light sometimes feels as though it has pushed out all of the air and filled the vacuum. The way the light simultaneously surrounds and hovers above the landscape is how Brophy approaches his paintings. Brophy simply floods his scenes in this light with a matter-of-factness about why such mundane subjects are worthy of paintings and further contemplation.

In choosing his subject matter, Brophy seeks provocative images of the forest to refocus attention on aspects that are taken for granted or deliberately overlooked. He has garnered critical acclaim for his paintings of clear-cut mountainsides, images that appear only to mirror the devastation. The art critic Matthew Kangas notes that "despite sharing the size and much of the inflated, quasi-religious grandeur of Albert Bierstadt and other painters of the Rocky Mountain School, Brophy's paintings set out to expose the ecological aftermath of Manifest Destiny: the 'colonization' and subsequent destruction of millions of acres of virgin-growth forests."[28] Although this commentary responds to the obvious imagery favored by Brophy, it does not fully account for the social context and intent of Brophy's agenda. Canvases such as *Key* encourage a rethinking of the relationship between humans and the environment (Fig. 11).

Artworks in this vein reflect the profound impact that humans have made on the environment. It is irrefutable that men and their machines have removed natural material. Yet, the paradox exists that this removal of the resources would not be possible without the existence of the very same resources. Throughout American history, the ability to extract resources has been celebrated as well as lamented. This theme is a vital one in the history of late-nineteenth-century American painting.[29] It also has attracted the attention of more contemporary thinkers such as Leo Marx, whose seminal text *The Machine in the Garden* remains invaluable.[30]

It is important to note that Brophy's paintings are not of the virgin forests (areas that were not harvested during the first waves of logging) that remain at the center of the most contentious political and legal fights. Rather, his scenes are of the second-growth forests that have been managed for decades by volumes of federal and state regulations. Most often, Brophy depicts sites from the region of the Tillamook Burn. *Fire*

FIGURE 11
Key, 1994
(DETAIL, SEE FIG. 1)

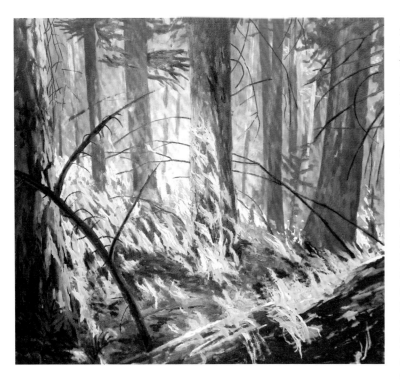

pays homage to the great conflagrations that fill the imagination of Oregonians (Fig. 12). The repeated fires, which destroyed tens of thousands of acres of timber, serve as a reminder that not all natural forces can be groomed to suit human desires.

In a strictly art historical sense, Brophy's images fall into the paradigm of painting the West as an exercise in recording what is there. Of course, Brophy's response is a bit less awestruck, and he is far more resolved to understand the changes to what is pre-sumed to be "wild" or "natural." However, he never fully eradicates those aspects of the scene. Brophy manages to show the forces of nature in full. In the middle ground of *January*, he evokes the bone-rattling chill of a mid-winter's rainstorm (Fig. 13). He translates the rain into brushstrokes. Clouds rise from the mountains. Colors meld to indicate sloppy mud on a logging road. Fleeting and diluted colors imply distant, tree-covered slopes. There is high optimism that nature will regenerate another forest.

Looking at the scene with steel will and a wide and pragmatic scope, Brophy sees far more than environmental devastation.[31] He uses his paintings to raise difficult questions: Why does this section of land look like this? How should forests be used for maximum, long-term benefit? These regions, seemingly uninhabited, are actually social spaces. Following in the WPA-era tradition, the focus of such a clear-cut should be directed to how people shaped the terrain. Other earlier Northwest artists such as Kenneth Callahan (1905–86) clearly understood how closely people were tied to the land. His painting *Cascades* depicts a dour, logged mountainside (Fig. 14). It is not lost on Brophy that the melancholy of Callahan's scene is tempered by the knowledge that loggers needed jobs during the Great Depression and harvested timber provided for families, however modestly. He remarked about this process, although obliquely: "A very simple narrative structure of the Old Story, where you slash and burn, but out of that you build a city. One environment is being replaced by another."[32] Because humans can build an environment, they must be considered an inseparable part of it.

Recently this type of awareness has been labeled "environmental sustainability." Gro Harlem Brundtland employed this term in the seminal report *Our Common Future* in 1987 for the United Nations World Commission on Environment and Develop-ment. The report urged "development that meets the needs of the present without compromising the ability of future genera-tions to meet their own needs."[33] The idea of sustainable development has come to include a vast matrix of considerations, including ecological, social, and economic facets. It means balancing such dissimilar concerns as biological diversity, the need for forest products (wood, cellulose, etc.), water quality, jobs, soil conservation, and shareholder value, among many others.[34] It means stewardship. It is midway between the radically opposed extremes espoused by the "deep environmentalists," who urge preservation at all costs, and those of the

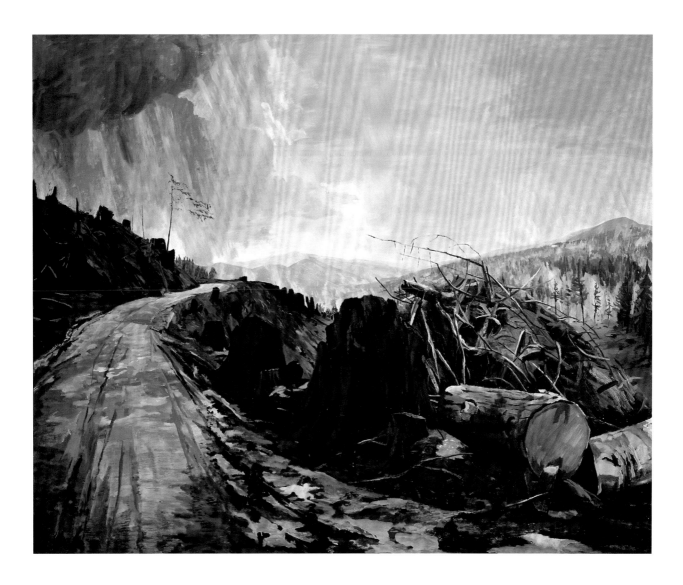

FIGURE 13

Michael Brophy,
January, 1997

OIL ON CANVAS, 78 × 96 INCHES
TACOMA ART MUSEUM, MUSEUM
PURCHASE WITH FUNDS FROM
THE DR. LESTER BASKIN MEMORIAL
FUND

FIGURE 14

Kenneth Callahan,
Cascades, ca. 1935–39

GOUACHE ON PAPER, 21 × 31⅜ INCHES
TACOMA ART MUSEUM, GIFT OF THE
ALOHA CLUB

"wise-use movement," who advocate the supremacy of property rights and minimal government regulations. The historian Richard White phrased this particular set of oppositions succinctly: "The choice between condemning all work in nature and sentimentalizing vanishing forms of work is simply not an adequate choice."[35] His essay "'Are You an Environmentalist or Do You Work for a Living?': Work and Nature" was included in a highly contentious volume of essays, *Uncommon Ground: Rethinking the Human Place in Nature*, edited by William Cronon. The purpose of the volume was to "encourage greater reflection about the complicated and contradictory ways in which modern human beings conceive their place in nature."[36] Throughout the book, the authors frankly observe that humans impact the landscape because people work the landscape to generate the products that are necessary for basic life. White directs his attention to those environmentalists who take this for granted:

> Most environmentalists disdain and distrust those who most obviously work in nature. Environmentalists have come to associate work—particularly heavy bodily labor, blue-collar work—with environmental degradation. This is true whether the work is in the woods, on the sea, in a refinery, in a chemical plant, in a pulp mill, or in a farmer's field or a rancher's pasture. Environmentalists usually imagine that when people who make things finish their day's work, nature is the poorer for it. Nature seems safest when shielded from human labor.[37]

He explains why this is inadequate:

> I have phrased this issue so harshly not because I oppose environmentalism (indeed, I consider myself an environmentalist) but precisely because I think environmentalism must be a basic element in any coherent attempt to address the social, economic, and political problems that confront Americans at the end of the century. Environmentalists must come to terms with work because its effects are so widespread and because work itself offers both a fundamental way of knowing nature and perhaps our deepest connection with the natural world.[38]

Brophy comes to this point of view from pragmatic and experiential reasons rather than White's academic grounding. The changes wrought by humans to the forest ecosystem are often necessary and beneficial to our society and the individual. Brophy knows individuals whose livelihood depends on forests: loggers, truck drivers, and mill workers as well as many folks who live in areas economically dependent on resource extraction. Brophy's paintings of clear-cuts or portraits of snags need to be understood in this respect.

Like White's blue-collar workers, Brophy understands that the landscape is a place to earn a living. This understanding contradicts many of our society's notions about landscape painting, such as those partially informed by the nineteenth-century Hudson River school. American landscape artists of the mid-nineteenth century sometimes included a curtain in front of their monumental paintings of the landscape to enhance the natural drama.[39] This usage referred to the stage set, emphasizing the operatic qualities of the landscape.

The notion of an artificial and idealized landscape provides ample ground for Brophy. The motif of a stage curtain is another way that Brophy prompts people to rethink long-held assumptions about the landscape. By including the curtain as an inseparable component of his compositions, he literally

sets the stage for viewers to reexamine the philosophical and spiritual underpinnings of their relationship with the forest. In *Small Curtain*, the deep maroon curtain seems to signal the end of an act (Fig. 15). The narrative action on stage nears its climax, leaving the stage packed with actors, trees that drove the plot forward by simply growing vertically. As it inevitably must, the story will end with a harvest—the very purpose that the trees were so rigidly arranged. *Heart of the Cascades* uses the curtain in the painting tradition, which can be traced back to the Italian Renaissance (Fig. 16). Draped and pulled back, the yards of heavy curtains signal a distinct separation between the otherworldly image generated by the artist and the actual, physical world.

Brophy intertwines meanings from both the Renaissance and nineteenth-century painting conceits. The curtain becomes a device to signal that artificiality is Brophy's underlying message. He sets a stage on which the falsity of an existing, ideal landscape stands. The notion of a pristine, wild, and timeless place exists solely in the imagination. In essence, Brophy consistently returns to the subtle but pervasive ways that social forces continually reshape perceptions of the landscape. The tension between differing forces creates the political maneuvering and posturing. How Brophy navigates these shifts was noted by author James King-Loo Yu: "His postheroic presentation of the subjects he depicts gives an impression that a grand algebra has been set in motion with equilibrium inevitable. Even human intrusion and disruption can be seen on a larger scale as a reorganization of environmental balance; nature is a social construct, after all."[40]

The subject of nature as a social construct has been thoroughly covered in respect to American art.[41] Brophy continues working in this tradition by linking the actual landscape with complex social and political issues. The critic Jonathan Raymond summarized Brophy's agenda:

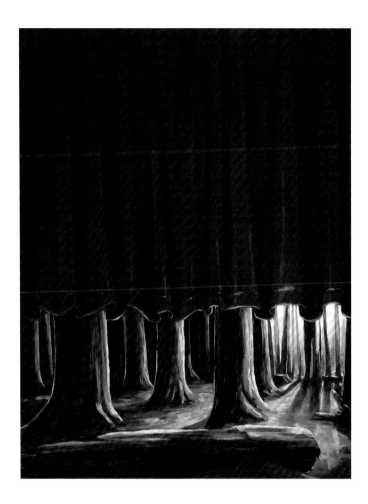

"Indeed, Brophy's paintings are less about the secrets of the land itself than the secrets of how people look at the land—the way we gaze at vistas we've already seen a million times as if something unknown lived there, how we pretend the view from the trail wasn't framed for us a hundred years ago."[42] Brophy's paintings are powerful because he shows a place, how people think about it, and how they use it.

The Consequences of History

Brophy approaches the idea of history painting as he does the concept of landscape painting. He seeks subjects and creates images that allow him to insert a rethinking of generally held beliefs about the history of the Northwest. These images explore how such beliefs shape current-day self-perception. Beginning with the

FIGURE 15
Small Curtain, 1999
OIL ON CANVAS, 49 × 37 INCHES
SAFECO ART COLLECTION

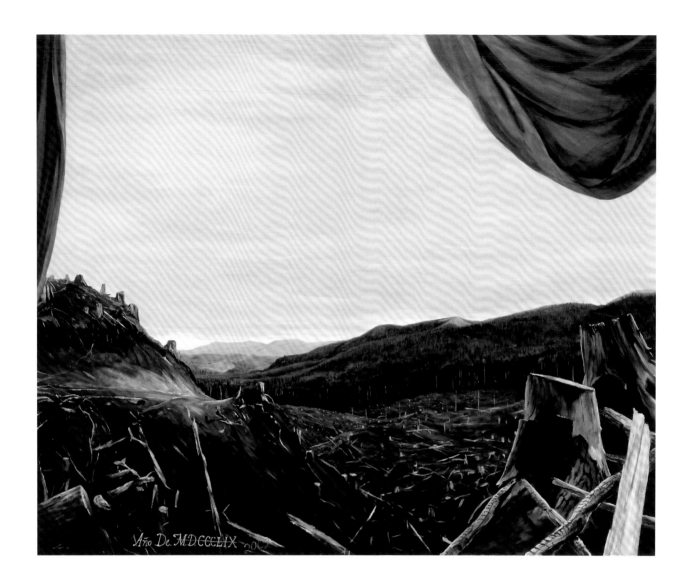

Año De. MDCCCLIX 200

English and American fur traders of the early nineteenth century and moving through generations to Woody Guthrie's whirlwind tour of the Columbia Gorge in 1941, Brophy filters the commonly accepted historical narrative through his sardonic wit and personal experiences.

There is a melancholic sense of loss for the wily frontiersman, the swaggering logger, or the steamer captain with his unflappable bravura. The factual and legendary characters that populate Brophy's history paintings are his tribute to the hopes, hard labor, and occasional folly that drove the settlement and development of the Northwest. He plucks these characters from their historical context and transplants them into tableaux in which they confront the legacy of their actions. His paintings tell the story of their mythic proportions rather than their deeds. Their personal qualities—hardworking, optimistic, risk-taking, independent, clever, and a host of other cherished and deeply ingrained traits—become a mirror to define today's widespread sense of self. With this shift from the historical legends to self-identity, Brophy emphasizes how such characters activate a sense of historical consequence.

The theoretical background for Brophy's approach is intriguing. Arts writer Slats Grobnik described the mechanism of Brophy's history paintings: "Like Walter Benjamin's much-invoked angel of history, flying backwards into the future, Brophy's paintings use hindsight to clarify just how little is really known about the here and now, and likewise, about what the rest of time holds in store."[43] Brophy's general "formula" for these paintings begins with obviously historicizing images inserted into present-day circumstances. Creating pictures that represent "the golden days" in our collective memory, he plumbs both the historical archives as well as stereotypical imagery. Brophy employs the literary device of irony, the realization that actions lead to unexpected consequences. For Brophy, the

legacy of history is not something that fades, but it remains a vital force that shapes social interactions. Through his paintings, he asks why and how personalities and decisions in the distant past still resonate.

In strictly chronological terms, Brophy's paintings of Northwest history begin with the Hudson's Bay Company and the influx of Europeans and Americans searching for beaver pelts. The labor and goals of these first Anglo-European immigrants opened the area for swift change. It placed the territory onto the map, literally, and made it one facet of international trade and political machinations.[44]

For Brophy, the attraction to this subject is its absurdity. How could a place that was completely unknown become a rich source of beaver fur and a revenue stream for a London-based trading company, lead to an influx of American settlers, utterly alter the balance of biodiversity in the region, and be the subject of international treaties that barely prevented the outbreak of war? This sequence then resulted in a second influx of American settlers arriving along the Oregon trail, which, in turn, led to the establishment of increasingly larger settlements, which produced working farms and timber operations that exported their goods to other sections of the growing United States, which ultimately resulted in the growth of the metropolis Portland, Brophy's hometown. Brophy ponders this unlikely string of events in the triptych *Twilight of the Beaver Trade*, *Stark's Claim*, and *Pastures of Plenty* (Fig. 17.1–3). The sequence includes an anonymous historical figure assessing the Willamette River as a source for pelts, the towering ghost of Benjamin Stark (one of the founders of the city of Portland) standing over a burgeoning town, and a glowing beaver hat magically hovering over an electrified metropolis. Within each panel, the Willamette River winds around the same bends timelessly—over the course of two centuries.

FIGURE 16
Heart of the Cascades, 2002
OIL ON CANVAS, 78 × 96 INCHES
COLLECTION OF THE ARTIST,
COURTESY OF LAURA RUSSO
GALLERY, PORTLAND

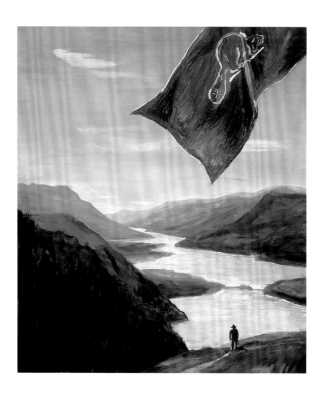

FIGURE 17.1

Twilight of the Beaver Trade, 2000

(TRIPTYCH, DETAIL)
OIL ON CANVAS, 19½ × 17 INCHES
PRIVATE COLLECTION

FIGURE 17.2

Stark's Claim, 2000

(TRIPTYCH, DETAIL)
OIL ON CANVAS, 19½ × 17 INCHES
PRIVATE COLLECTION

FIGURE 17.3

Pastures of Plenty, 2000

(TRIPTYCH, DETAIL)
OIL ON CANVAS, 19½ × 17 INCHES
PRIVATE COLLECTION

FIGURE 18

Beaver Trade, 2002

OIL ON CANVAS, 78 × 84 INCHES
COLLECTION OF THE ARTIST,
COURTESY OF LAURA RUSSO
GALLERY, PORTLAND

Another painting, *Beaver Trade*, pays homage to the deliberate decision by George Simpson, head of the Hudson's Bay Company from 1821 to 1856, to maximize the company's profits by trapping out all the beaver in the Oregon territory (Fig. 18).[45] An effigy of Simpson carved in a wood pole looks over a broad stretch of the Columbia River, now depleted of its former bounty of fur-bearing creatures. In Brophy's painting, Simpson's westward gaze toward the setting sun represents his decision to end the viable fur trade, but it also represents his role in stimulating future developments of the Columbia River basin as an economic engine. Brophy, typically, includes a number of absurdities. The tiny figure of Simpson signals the disconnect between his small physical stature and his ability to destroy the ecological balance of a region. The comic-book style "X" marks over the dead beaver's eyes belie the seriousness of the changes wrought by Simpson and, irreverently, how difficult it is to convey this to contemporary audiences. Lastly, the river at flood stage contradicts the stated

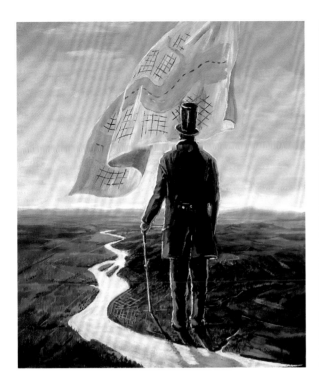

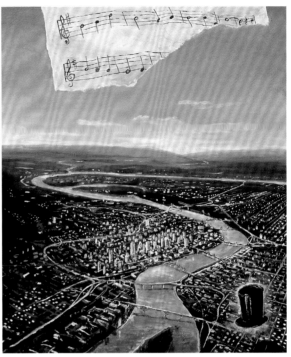

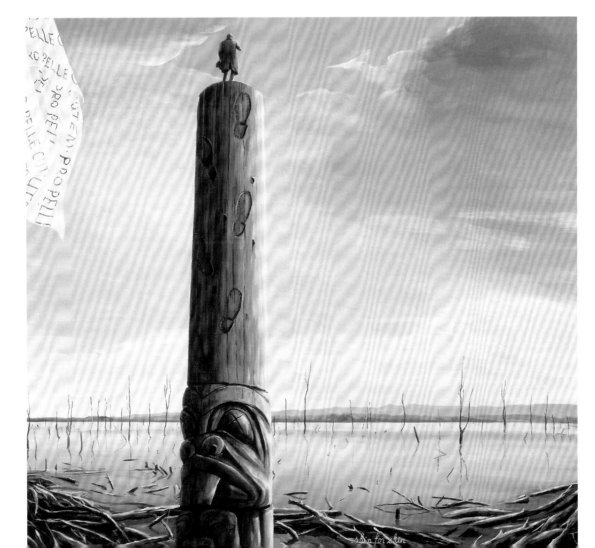

a. Range

b. Portrait

FIGURE 19.1–26

Columbia River Jargon,
2001

GOUACHE ON PAPER,
7½ × 5 INCHES EACH
MILLER MEIGS COLLECTION,
CORVALLIS, OREGON

policy of the Hudson's Bay Company to create a "fur desert."

The Columbia River is central to the history of the region and, consequently, a mainstay in Brophy's iconography.[46] Native Americans depended on the river. Early mariners charted it. Lewis and Clark explored it. Trade flourished on it. The federal government rechanneled and dammed it. Brophy explores the constant presence of the river in the series of gouache paintings *Columbia River Jargon* (Fig. 19.1–26). By linking his understanding of the river's history to the trade language that developed between Europeans and indigenous people who settled near the river, Brophy emphasizes the river's primacy in the region's history. His images illustrate the symbols that permeate the self-identity of most residents: Native Americans, early sailing vessels and charts, beavers, statehood, timber, salmon, hydroelectric dams, and cities.

By the early 1930s, the technical abilities and desire to alter radically the flow of the river existed. Part land reclamation, part social engineering, and part economic stimulation, the federal government decided to control the flow of the mighty Columbia.[47] Founded in the Depression era, the Bonneville Power Administration built a series of hydroelectric dams to supply cheap electricity and jobs. Not only did the dams live up to their promise of "turning our darkness to dawn," they also created a host of new industries and a literal forest of transmission lines and towers.[48]

Woody Guthrie, who was escorted from project site to project site on the dam in a luxurious motorcade in 1941, brought the river and region to national prominence by singing newly composed folk songs about the region. With titles like "Talking Columbia Blues" and "Roll on Columbia," Guthrie's response to the dam-building projects colored the nation's view of the Northwest. He sang of salmon, locks, Grand Coulee and Bonneville dams, and electricity.

c. Run

d. Canoe

e. Clippership

f. Label

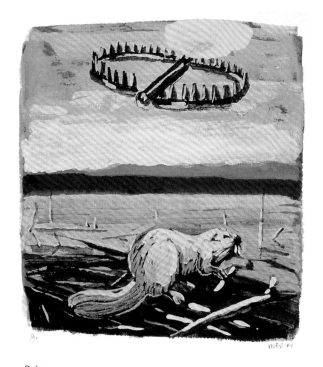

g. Pelt

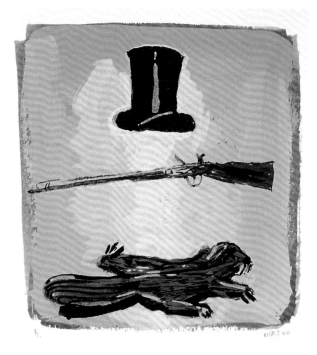

h. Trade Tower

i. Father John

j. Smallpox

k. Malaria

l. Claim

m. The Happy Merchant

n. Steam and Navigation

o. Springboard

p. Benson Raft

q. Fish Wheel

r. Channel

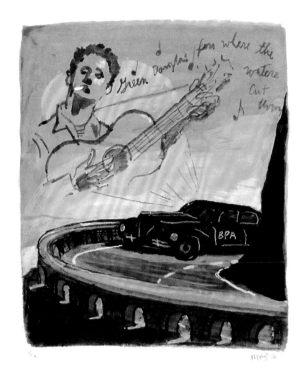

s. BPA

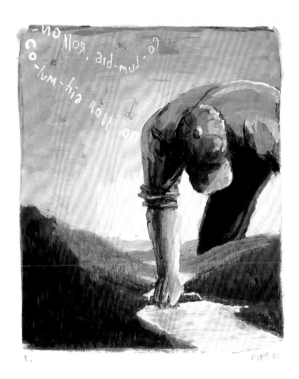

t. Dam

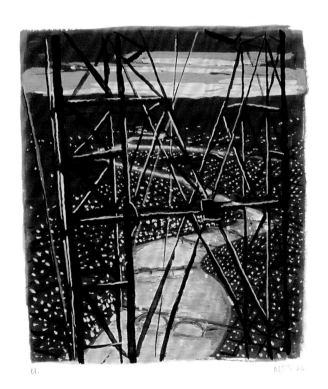

u. Power Grid

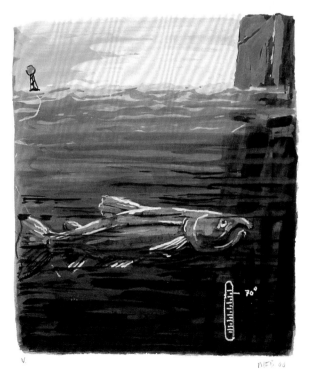

v. Fatigue

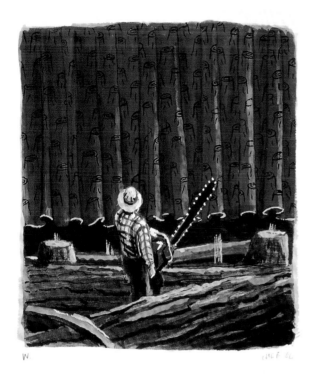

w. The Stump Curtain

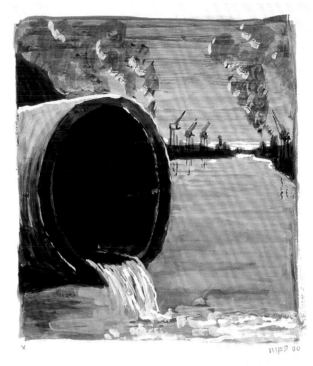

x. Overflow

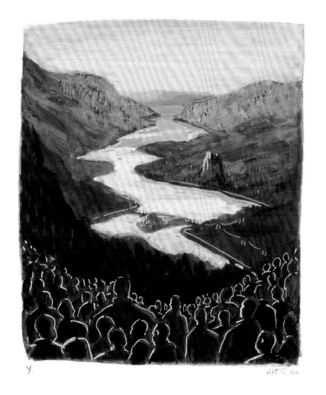

y. The Spiritual Moment

z. City Coat

Richard White noted the illogicality of the entire Columbia River dam program:

> Close distinctions between boon-doggles and building up the country did not overly concern western boosters. Both could provide local benefits. But dams on the Columbia presented a particular challenge, for they were neither boondoggles nor clear economic progress. The very benefits they provided were their major problem. Dams would improve navigation on a river where existing navigational improvements were unused. They would bring more land into production in a country where farmers were already plagued by overproduction and low prices, and they would provide immense amounts of power which no one wanted to buy.[49]

The ability to complete the project, a technical marvel of the highest order, also required that the entire society embrace the possibilities for the future. People had to overlook the obvious and begin to think as though the dams had always been a part of the available resources.

Brophy delights in the absurdity that these massive changes to the landscape are virtually unnoticed today. In *Gorge*, he pins his composition on the complex grid of a transmission tower (Fig. 20). The focal point is not the geometry of the tower but the expanse of the river gorge and the slack-water dam in the distance. Unlike the Depression-era belief in the limitless benefits of technological progress, Brophy finds complication in this history. What is so fascinating is that the apparatus of technological change is now taken for granted. The entire infrastructure is invisible because it is such an integral part of daily life. The towers, "lakes," and concrete dams are now fundamental components of the Northwest landscape.

The freeways and roads that move goods and people (another crucial portion of the infrastructure) have also divided the land into orderly blocks. Cities and suburbs are neatly arranged, and navigation is easier because of this system. This view of the land comes from the Jeffersonian solution to survey the land into rectilinear sections as ordered by the Land Ordinance of 1785, which sprang from the New England township system. The value of this system lies in its use for the legal and orderly exchange of property. In 1851, it was decided to set the origin point for all land surveys in the Pacific Northwest at the Willamette Stone.[50] All properties were described by their relationship to this starting point, which is located in the hills about four miles northwest of Portland. The photographer Carleton Watkins (1829–1916) made a panoramic photograph of the burgeoning city of Portland near this point in 1867 (Fig. 21.1–3). The grid structure is immediately apparent. From this handful of city blocks, fortunes were acquired and the economic course for the region was decided. Eventually, a metropolis rose.

Survey commemorates the influence of Watkins as an artist and this early development of Portland (Fig. 22). Brophy's composition borrows liberally from the Watkins photograph, but he compresses all of Watkins's visual clues to the city into a single canvas. This concentration removes the typical nostalgic reactions to the quaintness of a "frontier settlement." Brophy also rearranges the snags to anchor the conceptual core of his painting—it is a painting about the development of a city carved from a forest.

Survey is also an art historical pun. Brophy again deliberately conflates two seemingly irreconcilable traditions, using standard devices refined in the Italian Renaissance (the banderole and the column) and photographic compositions based on the fascination with the geography of the American West. The banderole unfurling across the cloud-laden sky announces the location of the growing city as measured

FIGURE 20

Michael Brophy,
Gorge, 1999

OIL ON CANVAS, 78 × 84 INCHES
COLLECTION OF MR. AND
MRS. DAVID ROCHE

FIGURE 21.1–3

Carleton Watkins, *City
of Portland and the
Willamette River*, 1867
(TRIPTYCH)
ALBUMEN PRINTS FROM WET
COLLODION NEGATIVES,
16⅞ × 21⅜ INCHES EACH
OREGON HISTORICAL SOCIETY

FIGURE 22

Michael Brophy,
Survey, 1998

OIL ON CANVAS, 79 × 85 INCHES
PRIVATE COLLECTION

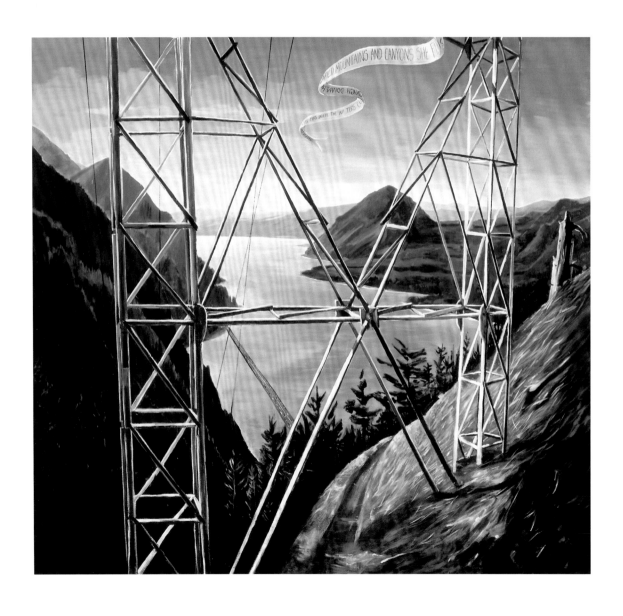

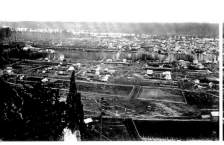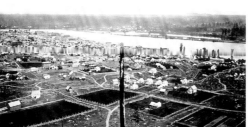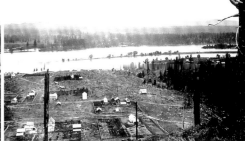

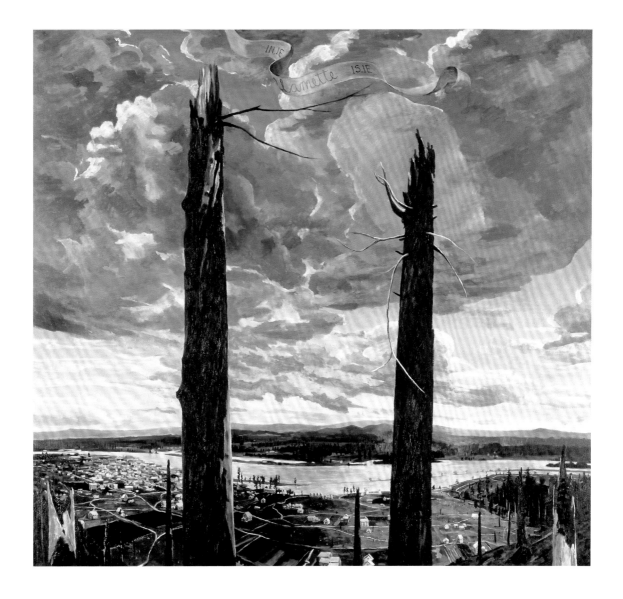

from the Willamette Stone. Like the motif of the curtain in front of the forest, this contrivance signals the artificiality of the image. Additionally, the snags stand like ancient Roman ruins reviving memories of long-past glory (see also Fig. 10).

The grid and skyline of modern day Portland is another of Brophy's favorite themes. In *Burnt Casing*, Brophy shifts the viewpoint from the Willamette Stone to that looking out from an anachronistic and nondescript window of an imaginary skyscraper (Fig. 23). The form of the window casing is that of a wood-frame home, not a sleek, modern office tower. Nonetheless, the perspective out of the window offers the same view: the organization of the downtown core, albeit more than a century after Watkins. Brophy provides another clue that guides the viewer to remember the humble origins of the city: the "wallpaper" has a repeating pattern of stumps on a dirt-brown background.

At the turn of the twentieth century, the city of Portland hosted the Lewis and Clark Centennial Exposition.[51] The business leaders of the city recognized that the economy of the region had to be diversified. They hoped that a successful exposition would showcase the economic advantages of Portland and its surrounding areas. The event ostensibly celebrated the voyage of Lewis and Clark with a "world's fair" that included a nod to the timber industry with a monumental architectural fantasy that housed the Forestry Pavilion. The building was a Greek-style temple of enormous proportions constructed entirely of unprocessed logs. The look was rustic and wild; yet, the pavilion stood as a monument to technical bravura. Brophy has dim memories of visiting the remains of the structure as a young child. It was ultimately destroyed by fire in 1964.

The Royal Court revisits the great hall and its colonnade (Fig. 24.1–3). The pavilion demonstrated the ongoing bounty of the forests and, even then, romanticized

FIGURE 23
Burnt Casing, 2001
OIL ON CANVAS, 61 × 49 INCHES
PRIVATE COLLECTION

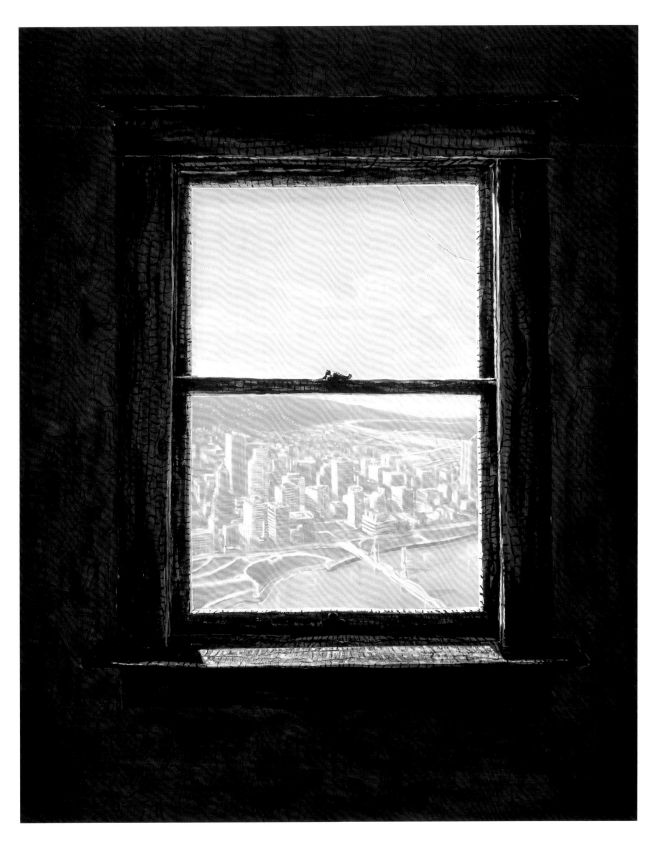

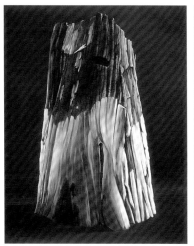 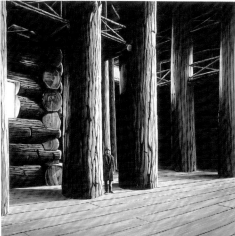 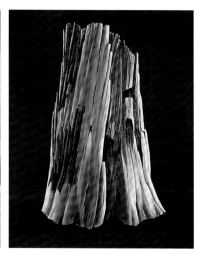

FIGURE 24.1–3

The Royal Court, 2003–04
(TRIPTYCH)
OIL ON CANVAS, 91 × 260 INCHES
OVERALL
COLLECTION OF THE ARTIST,
COURTESY OF LAURA RUSSO
GALLERY, PORTLAND

the history of the timber industry. Brophy's painting repeats this romanticizing gesture but simultaneously questions it. Brophy reminds contemporary viewers that the building material came from the forests by flanking the central panel with two of the snag portraits. Those two giant snags came into existence because the trees were harvested for an insatiable national and, increasingly, international marketplace.

Although this assessment is fairly harsh (in no small part because it purposely ignores the fact that some segments of the timber industry learned fairly quickly that harvested acreage must be restocked), Brophy is able to find some humor regarding the giant timber. In 2003, artists and curators in Portland presented *Core Sample,* a series of do-it-yourself art exhibitions spread across the city.[52] Brophy and Vanessa Renwick, a respected video artist who also lives and works in Portland, curated a project called "The Hunt," for which Brophy created the temporary *Pillar* (Fig. 25.1–2). He painted a poured-concrete supporting column to resemble a roughly hewn wooden beam. Although the pun was hilarious and

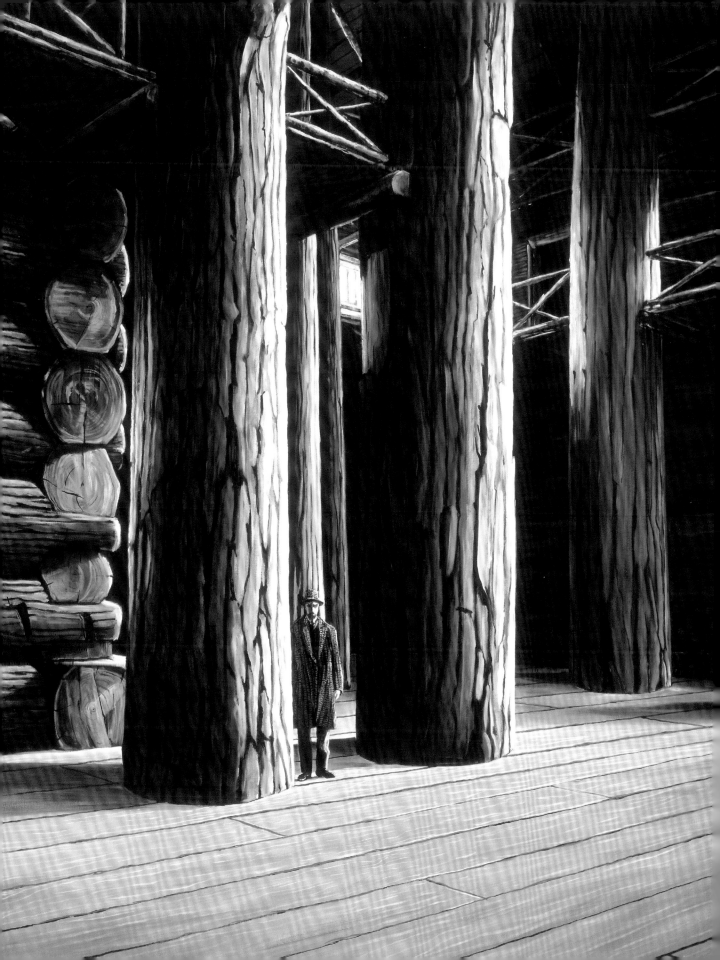

FIGURE 25.1–2
Pillar, 2003
ACRYLIC ON CONCRETE, APPROXI-
MATELY 240 × 18 × 18 INCHES
TEMPORARY, SITE-SPECIFIC
INSTALLATION IN THE BELMONT
BUILDING, PORTLAND, OREGON

FIGURE 26
Old Growth, 2002
OIL ON CANVAS, 74 × 94 INCHES
COLLECTION OF THE ARTIST,
COURTESY OF LAURA RUSSO
GALLERY, PORTLAND

ingenious, *Pillar* was noticed only by the most observant. It failed because of familiarity: the city is filled with old warehouses built with exposed giant beams.

Sometimes Brophy's humor, an oddly urbane mix of the wry and folksy, is the dominating feature of his painting. *Old Growth* is another painting that plays off stereotypes (Fig. 26). It cheekily demonstrates that myths about the forest overlap and mingle in the minds of the region's residents. With a nod toward the beloved but maligned genre of chainsaw sculptures, Brophy depicted four icons—Sasquatch, Paul Bunyan, Smokey Bear, and a monstrous grizzly bear—as wooden sculptures, each standing on a stump, deep in the forest. This motley group is deeply ingrained in the lore of the Northwest. The characters come from divergent sources: children's stories, tall tales told in logging camps, contemporary popular culture, and the federal government. *Old Growth* relies on the ability of forest history to stir the imagination and keep generations of children and adults enthralled by myth.

The appeal of the forest is strong. Individuals seek their own sense of solitude, spiritual renewal, communion with nature, and adventure from the unpopulated areas. People joke about building a home overlooking a favorite viewpoint in order to make it "mine." *View* ponders this possibility (Fig. 27). A single figure takes a break from the task at hand and looks over a craggy valley. His work is revealed by the plans for a house lying on the tree stump in the foreground.

The impulse to own or control a part of the forest (or any other natural resource) is a powerful motivation that drives the history of the region. A painting like *View* shows this at a very personal level. A painting like *Survey* hints at the larger market forces driving decisions and actions (see Fig. 22). The history of the Northwest is a continual string of people searching for and seizing opportunities. Their desires and

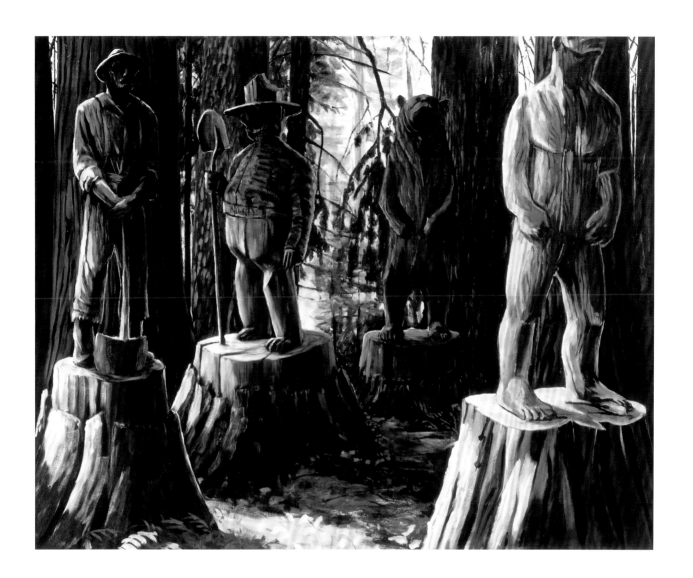

FIGURE 27
View, 1996
OIL ON CANVAS, 89 × 95 INCHES
BELL FAMILY COLLECTION

labor built a community. Understanding the consequences of their actions is equally tragic, humorous, inspiring, and edifying. For Brophy, understanding this history is a way to probe the possibilities of the future.

The Power of the Sublime

One of the persistent themes in landscape painting is the desire to convey the inestimable forces of Nature and the Divine. The beginning of this tradition can be traced to the earliest European landscapes from the late sixteenth and early seventeenth centuries.[53] By the late eighteenth century and throughout most of the nineteenth century, artists, poets, and philosophers expressed the supremacy of an individual's experience with the natural world as the truest and most meaningful access to the Divine.[54] Much of this was influenced strongly by writings, particularly Immanuel Kant's *Kritik der Urteilskraft* (*Critique of Judgment*, 1790) and Edmund Burke's *A Philosophical Enquiry into the Origin of our Ideas of the Sublime and Beautiful* (1756).

Kant and Burke both sought to articulate the human desire for something greater and more powerful (perhaps even mystical) that transcended the moribund impulse of Reason that had guided the Age of Enlightenment. Although differing substantially in their ideological approach, both philosophers believed that the optimal source for inspiration was the Sublime. They viewed the Sublime as a dynamic and powerful force that overwhelmed all of humanity, emphasizing the miniscule place of humans in the cosmic order. The force was virtually indefinable but inflamed the individual's imagination through terror or direct experience with the Divine.[55]

By the early 1800s, visual artists were able to articulate this emotional and spiritual experience through a variety of approaches, including mythological subjects, landscape, political commentary, and even phantasms. This artistic impulse, today known as romanticism, inspired

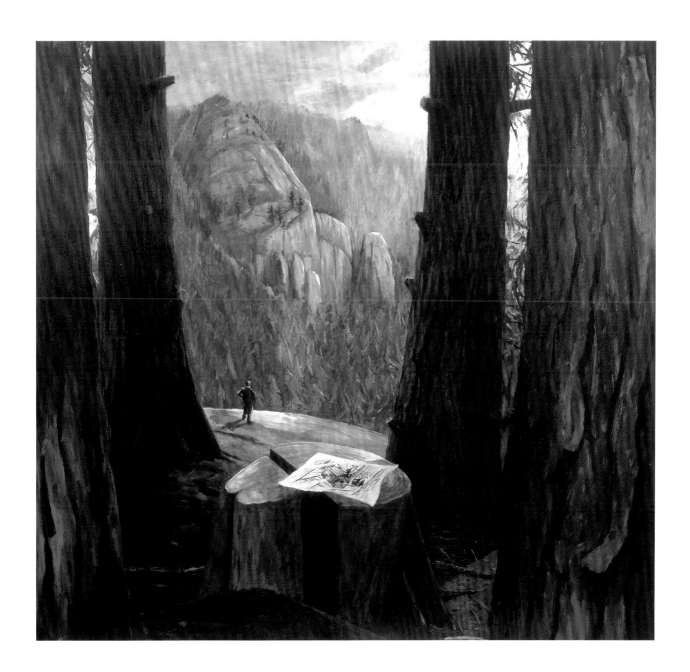

some of the works now considered the most important paintings in the Western tradition: Théodore Géricault (1791–1824), *The Raft of the Medusa* (1819); Francisco de Goya y Lucientes (1746–1828), *Saturn Devouring His Son* (1820–23); Eugène Delacroix (1798–1863), *Death of Sardanapalus* (1827–28); and Joseph Mallord William Turner (1775–1851), *Snowstorm, Steamboat off a Harbour's Mouth* (1842).[56] The common threads of the movement's obvious diversity are the artists' ability to appeal directly to emotion to navigate the complexities of the world; a penchant for violence, rebellion, exoticism, and bravura; and a belief that nature provided the only safe refuge from flawed and fallen civilization. The romantic artists also displayed a profound sense of nostalgia and more than a hint of irony.[57]

Above all else, the romantics celebrated the importance of the individual. Artists in the United States were also influenced by the romantic movement, but shaped by a distinctly American drive. Artists such as Benjamin West (1738–1820) and Thomas Cole responded most forcefully with moralizing allegories. West's *Death on a Pale Horse* (1796) and Cole's series such as *The Voyage of Life* (1842) are prominent examples. Landscape artists such as Asher B. Durand (1796–1886) and others of his generation responded to the individual's experience with nature, tempered and shaped by the American transcendentalists and Swedenborgian mysticism.[58] This particular response was nurtured by a fledgling nation seeking to define itself while rushing directly into the Industrial Revolution. Richard White described this synthesis: "[Ralph Waldo] Emerson reconciled nature with the busy, manipulative world of American capitalism. He reconciled utilitarianism with idealism; he reconciled the practical and the spiritual. When humans acted on nature they did not defile it, they purified it. 'Art was nature passed through the alembic of man.'"[59]

Throughout the nineteenth century, this mix of the Divine (often shortened to the phrase "nature as cathedral") and the celebration of economic and technological advances inspired countless landscape scenes.[60] This imagery was manifested primarily in the depiction of bucolic splendor, for example an isolated homestead nestled in a mountain valley that shelters a herd of cows. With the advent of photography, images of technologic achievements set into the wilderness (such as the transcontinental railroads) became part of the visual vocabulary. Lastly, geological marvels such as the Grand Canyon, Yosemite, and Yellowstone were featured by artists such as Thomas Moran and Albert Bierstadt. Moran in particular became known as a painter for the railroads, which used his imagery to promote tourism.[61] Remarkable for their impact as exquisite landscape images, these paintings are also notable for their value as cultural documents. There is a parallel between this development as a genre and the increasing confidence of the young nation. The paintings track the realization of Manifest Destiny.[62]

Michael Brophy's paintings deal with the remnants of the collision of Manifest Destiny and the Sublime. He urges reevaluation of the widely accepted notions related to the ideological positions defining the landscape. Many of Brophy's paintings deal explicitly with the notion of looking at the power of nature, a power now rendered nearly neutral by technology. This almost makes humans equal in creation. Rivers are rechanneled. Forests are removed and replaced repeatedly. A frontier settlement will grow into a metropolis. Brophy's goal is to prompt a new way of thinking about nature that also accounts for the presence and actions of humans. *Heart of the Cascades* and *View* represent his position on two radically different scales from the grand overview to the individual (Figs. 16 and 27). He shifts the focus from a search for the Sublime

FIGURE 28
By Moonlight, 1996
OIL ON CANVAS, 40 × 39¾ INCHES
WASHINGTON STATE ART COLLECTION IN PARTNERSHIP WITH TONASKET SCHOOL DISTRICT

or Divine to an individual's actions and responsibilities.

Brophy's painting *By Moonlight* illustrates the dreamlike possibility of logging by the light of a full moon (Fig. 28). *By Moonlight* edits out the complexity of this type of logging operation. Brophy's source is a photograph of a logger topping a tree in preparation for rigging a spar line.[63] It ignores the ground crew and the extensive preparations required for a safe and successful installation of the apparatus. The danger of such a foolhardy attempt is made nonexistent by the sensuous treatment of the murky light diluting the darkness. By submerging the logger in night's moonlight, Brophy shifts the attention from a yeoman's labor to a heroic act. The individual can alter the forest at his will. It is a splendid and moody exploration of the theme of human control of nature. The painting is an eloquent rendering of the myth of unbridled individualism set within nature's awesome power.

With images such as *Small Fish*, Brophy began to articulate more fully his position regarding the individual's response to nature and the environment (Fig. 29). In this mundane ritual repeated for generations, the barbeque serves as a metaphor for prosperity and bounty. The man cooking the fish was probably more concerned with the task at hand than any thought about the arrangements that brought the fish to his dinner. For many Americans, this outdoor cookery is their closest and most meaningful interaction with nature: a contained bowl of open fire used to cook a minimally processed food product. It is possible only because of an extensive infrastructure. It becomes fun to cook outside (like our distant ancestors did) and set aside the luxury of modern appliances in the name of a party. Such a stylized exercise of "getting closer to nature" inadvertently emphasizes how easily we can take nature for granted while still benefiting from its bounty.

In the dramatic, if surrealistic, painting *Fall*, Brophy considers what would happen

if a man were immediately and literally reinserted into nature (Fig. 30). The man, who is being dropped onto an arid mountainside, is a visual metaphor for the human condition without the mitigating factors that make contemporary human life pleasant: supermarkets, air conditioners, automobiles, rain-resistant clothing, such household electronic appliances as refrigerators and compact disc players, indoor plumbing with hot water on demand, and so forth. In contrast to the power of the individual in *By Moonlight*, the figure in *Fall* is rendered helpless by the power of nature. Stripped of technology and community, the figure is at the mercy of nature.

Above all else, the figures in *Fall*, *Small Fish*, and *By Moonlight* face nature in isolation. The single figure distills Brophy's romantic vision. The state of solitude for the artist was a crucial and idealizing theme for the romantic painters. It allowed them to highlight the artist's function outside the current of general society and independent of its mores and restrictions.[64] Most often Brophy depicts himself as this single figure, secluded and surrounded by the forces of nature. For Brophy, the single figure allows him to ponder the relationship between the individual and nature—a barbequed fish and infrastructures; clear-cuts and environmental sustainability; gravity and compact disc players; a frontier settlement and the modern metropolis. Brophy described the immediacy of this symbiotic interaction as "Man pushing up against nature, while nature pushes up against man."[65] The solitary figure serves as a metaphor for two interdependent themes. He is "everyman," and he is also a catalyst for rethinking assumptions about landscape and history.

Usually placed squarely in the center of the canvas, Brophy's figure serves as a guide or mediator, offering information about the scene. The subject of these paintings is not the obvious motif of Brophy himself within the landscape, but rather, a manner of seeing and thinking about the environment.

FIGURE 29
Small Fish, 1991
OIL ON CANVAS, 59 × 35 INCHES
COLLECTION OF TONKON TORP, LLP,
LAW FIRM

FIGURE 30
Fall, 1993
OIL ON CANVAS, 60 × 54 INCHES
MICROSOFT ART COLLECTION

Because his compositions direct attention by forcing viewers to substitute themselves for his painted self, the focal point of the composition is the vantage point directly in front of the figure and viewpoint of Brophy.

He appropriates this theme from the German romantic painter Caspar David Friedrich (1774–1840) (Fig. 31). Termed *Rückenfigur* (the "halted traveler"), this character has a long tradition in European painting. Notable examples can be found in the paintings of Giotto (1266 or 1267–1337) and Jan van Eyck (ca. 1390–1441). Figures are placed with little relationship to the main narrative in such paintings as Giotto's *Annunciation to Zacharias* (ca. 1315) in the Peruzzi Chapel in the church of Santa Croce in Florence and Jan van Eyck's *Madonna with Chancelor Nicolas Rolin* (ca. 1435). The artists included staffage as a mechanism to situate people within landscape. The figure offered the possibility of ornamentation and scale, depicting the minuscule role of humans and the existence of forces greater than humankind. Perhaps most importantly, as the motif saturated the landscape tradition it was an unmistakable sign that the artist created a scene with deep significance.[66] Friedrich's friend and follower Carl Gustav Carus (1789–1869) described another vital role of the character: "A solitary figure, lost in his contemplation of a silent landscape, will excite the viewer of the painting to think himself into the figure's place."[67] In this way, the *Rückenfigur* was a mediator between the artist and the viewer and between nature and human thought.

The importance of the motif of the *Rückenfigur* comes from the emphasis of the individual experience as described by Kant and other contemporaneous philosophers and poets. The individual must experience the Sublime. Kant wrote: "When we speak of the sublime in nature we speak improperly; properly speaking, sublimity can be attributed merely to our way of thinking."[68] Each individual must have his or her own

experience. It is simply impossible for the feelings and awareness to be transmitted in any other form.

Unlike Friedrich and his romantic contemporaries who sought direct access to spiritual power and an understanding of divine purpose, Brophy uses the standing figure as a filter or a lens. This figure represents an awareness of the capacity of mankind to alter radically the existing order and challenges assumptions about which actions are necessary in terms both of resource extraction and environmental preservation. In Brophy's paintings and thinking compared with his romantic predecessors, there is a distinct shift from thinking about landscape as a manifestation of the Divine to the stark realization that mankind must make a meaningful and long-term commitment to environmental sustainability. People are responsible for the state of the environment.

One of the unusually difficult aspects of Brophy's paintings is that they introduce a paradox and avoid resolution. Viewers often assume that the painted figure will direct attention or the gaze toward a simple solution to these issues. Brophy deliberately sidesteps this form of didacticism. The art critic Randy Gragg noted that "in Brophy's tragicomic theater, the standard actor is a lone figure, ambiguously either happy hiker or lucky logger—yet always small and weak, submerged in the inviting lap of the forest's scary voluptuousness."[69] Because the scale and emphasis of the solitary figure is significantly shifted in Brophy's painting compared to Friedrich's, Gragg's observation might not perfectly describe his relevance—the human being is not subordinate to nature any longer.

Like Friedrich, Brophy centers these compositions on the figure. The art historian Joseph Leo Koerner described Friedrich's *Rückenfigur* as the new locus: "Upon him, rather than on some constructed vanishing point in the distance, all lines of sight converge, as if landscape were mapping of world to body."[70] For Brophy, every aspect of the depicted natural world comes back to a comprehensive and pragmatic awareness of the human place in nature. No longer is it possible to separate nature from mankind. People shape and reshape; use and reuse; celebrate and destroy nature.

The series of paintings *Air*, *Earth*, *Fire*, and *Water* represent the terrain in its various guises as humans create or frame it (Fig. 32.1–4). *Air* is a vista overlooking a valley and emphasizes the scale of the forestlands. *Earth* confronts the remains of an area cleared by logging. The title suggests the earthy smell of upturned dirt and the source of the regenerating forest. *Fire* has a double meaning: it is a protective force for humans in nature, providing warmth and a deterrent against wild animals, but it also a source of terror and destruction. *Water* is a slyly humorous commentary on the inevitable rain of the Northwest. A countless number of minuscule drops of falling water must be stored behind the hydroelectric dams to be converted later into electricity. Brophy's humor plays on both the seeming inevitability of rain and the need to store more water, even given the enormous flows of the Columbia River.

In the painting *Measure*, Brophy contemplates a dead tree and its centuries-old history as part of the forest (Fig. 33). The title *Measure* refers not only to calculations of the size of the stump compared to the size of the human but also the measure of what has been lost and gained (see Figs. 7–9 and 24.1–3). The measurement requires the viewer to consider the economic and political costs and gains as well as the radical changes to the visual environment. Brophy's melancholy picture also measures the span of time—the time for the tree to grow, the time for the harvest, and the time that will be required for the forest to regenerate. All these periods are measured against a single human life span.

The sense of foreboding in Brophy's *Measure* is muted, again, by his humor. This painting also pays homage to the

FIGURE 31

Caspar David Friedrich, *Wanderer über dem Nebelmeer* [*Wanderer Above a Sea of Fog*], ca. 1817

OIL ON CANVAS, 37 ⁵⁄₁₆ × 29 ⁷⁄₁₆ INCHES HAMBURGER KUNSTHALLE, HAMBURG, GERMANY, ON PERMANENT LOAN FROM THE FOUNDATION FOR THE PROMOTION OF THE HAMBURG ART COLLECTIONS

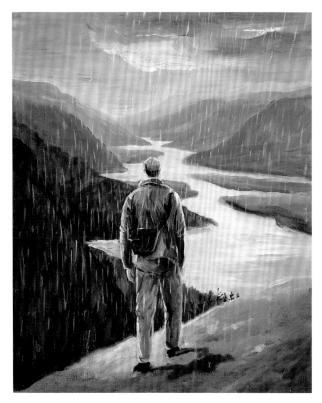

generations of loggers that created the image of the Northwest. In one of Brophy's favorite books about the timber industry, *Timber: Toil and Trouble in the Big Woods*, Ralph W. Andrews recalled: "In every camp there was a generous sifting of rebels, reactionaries, and the off-beat characters who colored the long days with the swish of a gaudy brush. The isolation and freedom of the big woods camps attracted and nurtured those rugged eccentrics who groped their way through life by dead reckoning and spiced it up for the rest of the timber stiffs."[71] There is also a sense of hope. Stewart Holbrook optimistically wrote about future growth: "My heart warms to the sight of mile upon mile of green young trees. In them, I like to think, are the sustaining factors for untold generations of lumberjacks, new style."[72] It is not inconceivable that Brophy casts himself here as one of Holbrook's "lumberjacks, new style." For Brophy, the measurement involves the past as well as the future, in addition to the specifics of the moment.

Brophy plays with the motif of the figure with *National Recreation Area* (Fig. 34). Unlike his other images in which the figure is a mere spectator struggling for comprehension, here he is an active force within the landscape. The golfer swings in an area formerly considered barren, useless, and threatening. It is an ironic commentary that unproductive terrain can be altered and marketed as a venue for recreation. As with the hydroelectric dams, man once again can match wits with the vagaries of geology. Untouched terrain for extreme sports such as whitewater kayaking, rock climbing, and backcountry biking is within minutes of perfectly groomed golf courses, tennis courts, and other more "civilized" forms of recreation. The outward push and development of new tourist/recreation areas depends on changing tastes. The associations of nature's awe and the Divine are transformed into value as recreation and status. The absurdity of a golfer teeing off

in a desert becomes a potent reminder that humans control the technology to reshape and reuse nature.

The grand spectacle, in which crowds of people all assume the role of *Rückenfiguren*, reveals Brophy's belief that the state of the Northwest landscape is a shared responsibility. *People's View* and *The Spiritual Moment* are Brophy's most elaborate paintings on this theme (Figs. 35 and 36). People, regardless of their ideological convictions or status, partake in the picturesque qualities of the terrain. They stand above the river gorge, an enormous queue waiting for their moment of enlightenment. Their commitment to this spiritual exercise is burdened by the presence of hundreds of people. This representation is meant to prod at the fallacy that the spiritual qualities believed to be inherent in the wilderness are in fact a philosophical construction, one analogous to the slack-water dam filling this bend of the Columbia River.

Of all his paintings, perhaps these two most clearly reveal Brophy's deeply held conviction that people must come together and forge a consensus about the future. Success depends on a common understanding of the region's past and the need for just and equitable policies regarding future land usage. It relies on the ability to understand that decisions about the landscape have benefits and costs and that preservation must be weighted to the requirements of sustainability. When this balance is eventually reached, the capacity to find both spiritual and material sustenance from the landscape will be more easily achieved.

FIGURE 32.1
Earth, 2000
(POLYPTYCH, DETAIL)
OIL ON CANVAS, 16¼ × 13½ INCHES
COLLECTION OF ARLENE AND
HAROLD SCHNITZER

FIGURE 32.2
Air, 2000
(POLYPTYCH, DETAIL)
OIL ON CANVAS, 16¼ × 13½ INCHES
COLLECTION OF ARLENE AND
HAROLD SCHNITZER

FIGURE 32.3
Water, 2000
(POLYPTYCH, DETAIL)
OIL ON CANVAS, 16¼ × 13½ INCHES
COLLECTION OF ARLENE AND
HAROLD SCHNITZER

FIGURE 32.4
Fire, 2000
(POLYPTYCH, DETAIL)
OIL ON CANVAS, 16¼ × 13½ INCHES
COLLECTION OF ARLENE AND
HAROLD SCHNITZER

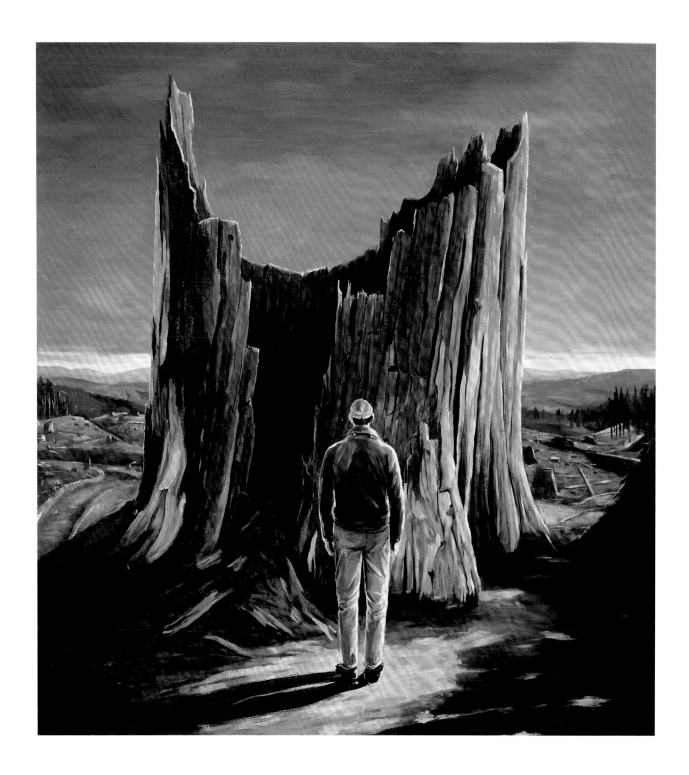

FIGURE 33

Measure, 2000

OIL ON CANVAS, 84 × 78 INCHES
REED COLLEGE ART COLLECTION,
REED COLLEGE

FIGURE 34

National Recreation Area,
2002

OIL ON CANVAS, 80 × 90 INCHES
COLLECTION OF THE ARTIST,
COURTESY OF LAURA RUSSO
GALLERY, PORTLAND

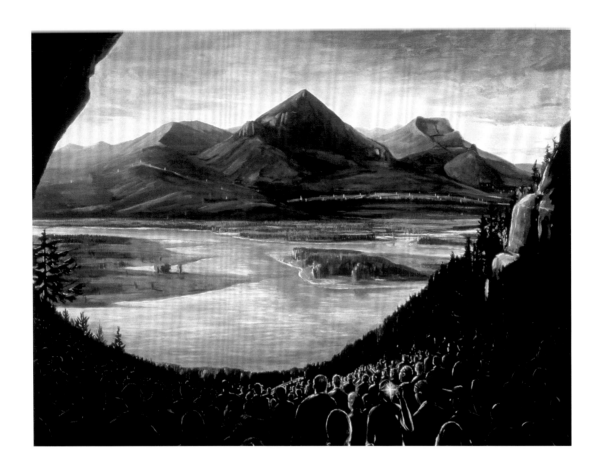

FIGURE 35

People's View, 1999

OIL ON CANVAS, 78 × 96 INCHES
PRIVATE COLLECTION

Michael Brophy's paintings celebrate the complexities, paradoxes, and conundrums of living in the Northwest. His renderings of the altered landscape and his quirky history paintings offer a spirited engagement not only with the visual impact of today's terrain but also the philosophical and intellectual underpinnings of self-identity. He seeks a deeper understanding of how people manage the incongruities between history and present-day opportunities and limitations.

To create his images, Brophy incorporates information from a broad range of disciplines, granting a richness and sophistication to his paintings. By activating history and environmental studies as well as folktales, humor, and wit, Brophy provides an opportunity to think about life in the American West, and the Pacific Northwest in particular, in terms that address why things look like they do. He simultaneously recasts preconditioned notions of the landscape—such as "pristine wilderness" and the Sublime—into eloquent statements that empower viewers to understand their personal responsibility for maintaining a sustainable environment. His oddly satisfying synergy allows both fact and fiction to color the issues relating to the environment facing our generation and generations to come.

Brophy's exquisite images of power transmission towers, slack-water dams, city skylines, forests, and snags gently encourage people to think about the future of the Northwest. Recalling generations of laborers and entrepreneurs, Brophy casts himself as a "lumberjack, new style" who searches for his own opportunity while seeking to preserve the region for posterity.

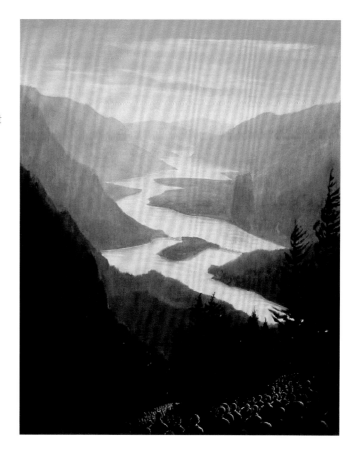

FIGURE 36
The Spiritual Moment, 2001
OIL ON CANVAS, 61 × 49 INCHES
PRIVATE COLLECTION

Notes

1. Ida Virginia Turney, *Paul Bunyan Comes West*, with illustrations by Helen Rhodes (Boston and New York: Houghton Mifflin Company; Cambridge, Mass.: The Riverside Press, 1928), 35–37.

2. Gro Harlem Brundtland, "Chairman's Foreword," in *Our Common Future: The World Commission on Environment and Development*, by World Commission on Environment and Development (Oxford, Eng., and New York: Oxford University Press, 1987), xi.

3. D. K. Row, "Brophy on Brophy," *Oregonian*, August 21, 1999, E1.

4. See Elizabeth Mankin Kornhauser, *Marsden Hartley* (Hartford, Conn.: Wadsworth Atheneum Museum of Art, in association with Yale University Press, 2002); and Nannette V. Maciejunes, Michael D. Hall, and Charles Ephraim Burchfield, *The Paintings of Charles Burchfield: North by Midwest* (New York: Harry N. Abrams, in association with the Columbus Museum of Art, 1997).

5. Portland Art Museum, *Portland Art Museum: Selected Works* (Portland, Ore.: Portland Art Museum, 1996), 9–13; and the author's conversations with Prudence Roberts, former Curator of American Art at Portland Art Museum.

6. For an argument against the notion of regionalist art as separate and distinct from the larger currents of American art, see my essay "Pride of Place in the Northwest," in *Building Tradition: Gifts in Honor of the Northwest Art Collection*, by Ivan Doig, Rock Hushka, and Patricia McDonnell (Tacoma, Wash.: Tacoma Art Museum, 2003), 17–28. Michael Brophy's *Snag I* (1997) is illustrated on page 26.

7. William Cronon, "Introduction: In Search of Nature," in *Uncommon Ground: Rethinking the Human Place in Nature*, ed. William Cronon (New York and London: W. W. Norton & Company, 1996), 23–56.

8. Richard White, "The Altered Landscape," in *Regionalism and the Pacific Northwest*, eds. William G. Robbins, Robert J. Frank, and Richard E. Ross (Corvallis, Ore.: Oregon State University Press, 1983), 110.

9. Eugene E. Snyder, *Early Portland: Stump-Town Triumphant: Rival Townsites on the Willamette, 1831–1854*, 2nd ed. (Portland, Ore.: Binford & Mort, 1984).

10. Ibid., vii.

11. V. L. O. Chittick, ed., *Northwest Harvest: A Regional Stocktaking* (New York: The Macmillan Company, 1948). The conference was held October 31 through November 2, 1946.

12. Peter H. Odegard, "The Question before Us," in *Northwest Harvest*, 14.

13. Ibid., 7.

14. Ernest Haycox, "Is There a Northwest?" in *Northwest Harvest*, 40–43.

15. Richard Maxwell Brown, "New Regionalism in America," in *Regionalism and the Pacific Northwest*, 64.

16. For a thorough discussion of George Caleb Bingham, see Nancy Rash, *The Painting and Politics of George Caleb Bingham* (New Haven, Conn.: Yale University Press, 1991). For Eastman Johnson's paintings, see Teresa A. Carbone, *Eastman Johnson: Painting America* (New York: Brooklyn Museum of Art, in association with Rizzoli, 1999). For a short but insightful overview of the development of twentieth-century regionalism, see Barbara Haskell, *The American Century: Art & Culture 1900–1950* (New York: Whitney Museum of American Art, in association with W. W. Norton & Company, New York and London, 1999). Another American scene painter of the nineteenth century who relates to this group is William Sidney Mount (1807–68). His career and genre scenes were the subject of a recent exhibition. See Deborah J. Johnson, *William Sidney Mount: Painter of American Life* (New York: American Federation of Arts, 1998).

17. Richard Maxwell Brown, "New Regionalism in America," in *Regionalism and the Pacific Northwest*, 71. Brown also noted this precise shift as a barometer of self-definition: "The classic dimension of western history and culture is that ordinarily referred to as the pioneer West or the Old West, with its distinctive mythology focusing on mountain men, cowboys, Indians, prospectors, gunfighters, and outlaws. The counter-classic West is, in terms similar to those of the South, the urbanized, industrialized, and modernized West characterized by recurring technological advance."

18. The scholarly literature on the legends of the Native American tribes collectively known as "Northwest Coast Indians" is extraordinarily rich. For an early overview, see Franz Boas, *The Growth of Indian Mythologies: A Study Based upon the Growth of the Mythologies of the North Pacific Coast*, vol. 9 ([Boston]: Journal of American Folklore, 1896). The work of Boas has been examined for culturally determined prejudices, and *The Growth of Indian Myth-ologies* must be read in this light. Another early volume that relates specifically to the central Puget Sound region is Thelma Adamson, *Folk-Tales of the Coast Salish*, vol. 27 (New York: The American Folk-lore Society and G. E. Stechert and Co., Agents, 1934).

19. James D. Proctor, "Whose Nature? The Contested Moral Terrain of Ancient Forests," in *Uncommon Ground*, 276.

20. Randy Gragg, "Transcending Politics, Embracing Paradox," *Oregonian*, September 18, 1995, D5.

21. Once radical, this is now accepted as orthodoxy. For a brief summary of the impact of indigenous populations in the Northwest in prehistory, see Richard E. Ross and David Brauner, "The Northwest as a Prehistoric Region," in *Regionalism and the Pacific Northwest*, 99–108. The impact of many native alterations to the landscape was often invisible. Richard White explained, "For centuries Indian peoples had been burning forests and prairies, encourag-ing some species and discouraging others; more recently, they had adopted exotic plants and animals such as the potato and the horse. The species composition of both the forests and prairies was to a significant degree the result of Indian practices. The Northwest that American settlers found was an Indian-managed Northwest." See Richard White, "The Altered Landscape," in *Regionalism and the Pacific Northwest*, 111.

22. See Carolyn Merchant, "Reinventing Eden: Western Culture as a Recovery Narrative," in *Uncommon Ground*, 132–59. Many of the paintings of Thomas Cole are obvi-ously grounded in this Puritan belief system; see William H. Truettner and Alan Wallach, eds., *Thomas Cole: Landscape into History* (New Haven, Conn.: Yale University Press; Washington, D.C.: National Museum of American Art, Smithsonian Institution, 1994).

23. For an overview of this, see Leo Marx, *The Machine in the Garden: Technology and the Pastoral Ideal in America*, 35th anniversary ed. (Oxford, Eng., and New York: Oxford University Press, 2000).

24. Many recent monographs discuss this aspect of nineteenth-century American landscape painting. For two examples, see Nancy K. Anderson, *Thomas Moran*, with contributions by Thomas P. Bruhn, Joni L. Kinsey, and Anne Morand (Washington, D.C.: National Gallery of Art; New Haven, Conn., and London: Yale University Press, 1997); Nancy K. Anderson and Linda S. Ferber, *Albert Bierstadt: Art & Enterprise* (New York: Hudson Hills Press, in association with the Brooklyn Museum, 1990). Anderson also explored how artists manipulated the market demand for frontier images; see "'The Kiss of Enterprise': The Western Landscape as Symbol and Resource," in *The West as America: Reinterpreting Images of the Frontier, 1820–1920*, ed. William H. Truettner (Washington, D.C., and London: National Museum of American Art, in association with the Smithsonian Institution Press, 1991), 236–83.

25. As cited in Alan Wallach, "Thomas Cole: Landscape and the Course of American Empire," in *Thomas Cole*, 51.

26. See http://www.co.missoula.mt.us/measures/forests.htm.

27. For brief histories of the Tillamook Burn, see Gail Wells, *The Tillamook: A Created Forest Comes of Age* (Corvallis, Ore.: Oregon State University Press, 1999); and J. Larry Kemp, *Epitaph for the Giants: The Story of the Tillamook Burn* (Portland, Ore.: Touchstone Press, 1967).

28. Matthew Kangas, "Seattle: Michael Brophy at Linda Hodges," *Art in America* 85 (February 1997): 110.

29. Kenneth W. Maddox, *In Search of the Picturesque: Nineteenth Century [sic] Images of Industry along the Hudson River Valley*, catalogue essay by Kenneth W. Maddox, contemporary site photography by Douglas Baz (Annandale-on-Hudson, N.Y.: Bard College, 1983), 41–45.

30. Marx, *Machine in the Garden*.

31. This line of thought was first published by Randy Gragg. "Brophy paints the forest, searching for the grandeur of the great Western painting tradition epitomized by Frederick [sic] Church and Alfred [sic] Bierstadt. But to those painters'

operatic rendition of the West as a stage for the grand 19th-century spectacle of Manifest Destiny, Brophy offers a clear-eyed, 20th-century, *fin de siècle* [*sic*] epilogue." See Randy Gragg, "Transcending Politics, Embracing Paradox," D5.

32. D. K. Row, "Brophy on Brophy," E1.

33. Quoted in Donald W. Floyd, *Forest Sustainability: The History, the Challenge, the Promise* (Durham, N.C.: The Forest History Society, 2002), 4. The full report was published as *Our Common Future: The World Commission on Environment and Development.*

34. Ibid., 5–8.

35. Richard White, "'Are You an Environmentalist or Do You Work for a Living?': Work and Nature," in *Uncommon Ground,* 181.

36. Cronon, "Introduction: In Search of Nature," in *Uncommon Ground,* 20.

37. White, "'Are You an Environmentalist or Do You Work for a Living?': Work and Nature," in *Uncommon Ground,* 172.

38. Ibid., 173–74.

39. The most celebrated instance in American art was Frederic Edwin Church's presentation of *Heart of the Andes* (1859) at the Metropolitan Fair in aid of the Sanitary Commission, New York, in 1864. A photograph documents Church's elaborate, dark, wooden frame with gilded additions, heavy drapery swathing the frame, and portraits of the nation's founding fathers. See Franklin Kelly, "A Passion for Landscape: The Paintings of Frederic Edwin Church," in *Frederic Edwin Church,* by Franklin Kelly, with contributions by Stephen Jay Gould, James Anthony Ryan, and Debora Rindge (Washington, D.C.: National Gallery of Art, 1989), 55–57. This device was used to spectacular effect by Italian painters of the late Renaissance and Baroque eras. Paintings such as Titian's (ca. 1488–1576) *St. John the Hospitaller* (ca. 1550) now at the church of S. Giovanni Elemosinario in Venice and Carravagio's (1571–1610) *Death of the Virgin* (1605–06) in the collection of the Louvre are icons of Western art.

40. James King-Loo Yu, "The Hunt: An Exhibition Curated by Michael Brophy and Vanessa Renwick," in *Core Sample: Portland Art Now,* eds. Randy Gragg and Matthew Stadler (Astoria, Ore.: Clear Cut Press, 2004), 250.

41. This is a well-honed argument and today is generally accepted by most academics. See Jules David Prown, *Discovered Lands, Invented Pasts: Transforming Visions of the American West,* with contributions by Nancy K. Anderson, William Cronon, Brian Dippie, Martha A. Sandweiss, Susan Prendergast Schoelwer, and Howard Lamar (New Haven, Conn., and London: Yale University Press, 1992); Maddox, *In Search of the Picturesque;* and Truettner, ed., *The West as America.*

42. Jonathan Raymond, "Forest Flaneur," *Anodyne* (August 1997): 34.

43. Slats Grobnik, "Forgotten Foundations: Recent Paintings by Michael Brophy," *Plazm* 21 ([first quarter] 1999): 28–31.

44. See Richard White, *"It's Your Misfortune and None of My Own": A History of the American West* (Norman, Okla.: University of Oklahoma Press, 1991), 71 and 77. For a more complete history, see Richard Mackie, *Trading beyond the Mountains: The British Fur Trade on the Pacific, 1793–1843* (Vancouver, B.C.: UBC Press, 1997).

45. Jennifer Ott, "'Ruining' the Rivers in the Snake Country: The Hudson's Bay Company's Fur Desert Policy," *Oregon Historical Quarterly* 104 (Summer 2003): 166–95.

46. For a concise rethinking of the Columbia River's history, see Richard White, *The Organic Machine* (New York: Hill and Wang, 1995).

47. Ibid., 59–88.

48. The phrase "turning our darkness to dawn" comes from the Woody Guthrie tune "Roll on Columbia":
Roll on, Columbia, roll on, roll on, Columbia roll on
Your power is turning our darkness to dawn
Roll on, Columbia, roll on.

49. White, *Organic Machine,* 54.

50. The history of the Willamette Stone is encapsulated by the End of the Oregon Trail Interpretive Center.

See http://www.endoftheoregontrail.org/road2oregon/
sa29surveys.html. The Oregon State Park system
preserves the site. See http://www.oregonstateparks.org/
park_246php. An image of the new marker placed by
the United States Geographical Survey can be viewed
at http://www.wmeridian.com/history.html.

51. Carl Abbott, *The Great Extravaganza: Portland and
the Lewis and Clark Exposition* (Portland, Ore.: Oregon
Historical Society, 1981).

52. Gragg and Stadler, eds., *Core Sample.*

53. These early tendencies can be seen in paintings by the
Dutch artists Esaias van de Velde I (1587–1630), Jacob van
Ruisdael (1628 or 1629–1682), and Meindert Hobbema
(1638–1709) as well as those of the Frenchman Claude
Lorrain (1604–1682). For a short overview of how thinking
about early European landscapes changed over the course
of a few generations, see H. Diane Russell, "Commentaries
on Claude's Art," in *Claude Lorrain: 1600–1682* (New York:
George Braziller, in association with the National Gallery
of Art, Washington, D.C., 1982), 417–33. In regard to the
earliest Dutch landscape painters, the draw to the subject
was a complex relationship between ideas of nationalism,
the pastoral, and classical and Biblical allusions. See Bob
Haak, *The Golden Age: Dutch Painters of the Seventeenth
Century,* trans. and ed. by Elizabeth Willems-Treeman
(New York: Harry N. Abrams, with the cooperation of the
Prince Bernhard Foundation, 1984), 134–46. Haak's text
also outlines Dutch landscape painting throughout the
seventeenth century, emphasizing regional developments.

54. For a concise and eloquent summary of the Sublime
in art, see David Rodgers, "The Sublime," In *The Dictionary
of Art,* ed. Jane Turner, vol. 29 (London: Grove, 1996),
889–91.

55. Ibid. See also David Blayney Brown, *Romanticism*
(London and New York: Phaidon Press, 2001).

56. Brown, *Romanticism.*

57. Ibid., 5–13.

58. These intellectual and spiritual influences were
particularly strong before the Civil War. They are distilled
in William Cullen Bryant's 1848 eulogy honoring Thomas
Cole. For the full text, see http://www.catskillarchive.com/
cole/wcb.htm (December 10, 2004).

59. White, *Organic Machine,* 35.

60. James Thrall Soby and Dorothy C. Miller, *Romantic
Painting in America* (New York: The Museum of Modern
Art, 1943); Anderson, *Thomas Moran;* and Anderson
and Ferber, *Albert Bierstadt.*

61. Anderson, *Thomas Moran,* 165. An exhibition of
paintings from the collection of the Santa Fe Railway
Company including works by Thomas Moran that were
commissioned for advertisements by that company was
shown at Tacoma Art Museum, April 13 through May 3,
1970; see Atchison, Topeka, and Santa Fe Railway
Company, *An Exhibition of Paintings of the Southwest from
the Santa Fe Railway Collection* [S.I. : s.n. 1966].

62. For an examination of the development of the concept
of Manifest Destiny, see Frederick Merk, *Manifest Destiny
and Mission in American History: A Reinterpretation,* rev. ed.
(Cambridge, Mass.: Harvard University Press, 1987). For
a recent examination of how Manifest Destiny impacted
nineteenth-century American art, see Truettner, ed., *The
West as America.*

63. Ralph W. Andrews, *Timber: Toil and Trouble in the
Big Woods,* 2nd ed. (Atglen, Penn.: Schiffer Publishing Ltd.,
1984), 167.

64. Brown, *Romanticism,* 36.

65. Conversation with the author, December 27, 2004.

66. Joseph Leo Koerner, *Caspar David Friedrich and the
Subject of Landscape* (New Haven, Conn., and London:
Yale University Press, 1990), 161–62.

67. Ibid., 211.

68. Ibid., 181.

69. Gragg, "Transcending Politics, Embracing Paradox," D5.

70. Koerner, *Caspar David Friedrich,* 179.

71. Andrews, *Timber,* 80.

72. Stewart Holbrook, "The Epic of Timber," in *Northwest
Harvest,* 95.

Artist's Biography

Michael Brophy is frequently labeled as the quintessential Northwest artist because of his clearly articulated pride of place. He was born in 1960 in Portland, Oregon, and earned his B.F.A. from Pacific Northwest College of Art in 1985. He has shown extensively in the Northwest, notably numerous one-person exhibitions in Seattle and Portland galleries and has been a frequent contributor to group exhibitions at the Portland Art Museum and Tacoma Art Museum. Among his numerous awards, he received a Western States Arts Federation NEA Fellowship in 1990, a Pollock/Krasner Foundation Grant in 1995, and the prestigious Artist Fellowship from Portland, Oregon's Metropolitan Arts Commission's Regional Arts and Culture Council in 2003. Since his first one-person shows in the early 1990s, he has received strong critical attention in the regional press as well as positive reviews in *Art in America.* He was published in *New American Paintings* (2001) and the important overview by critic Lois Allen *Contemporary Art in the Northwest* (1995). Works by Brophy were recently included in two significant touring exhibitions, *Lewis and Clark Territory: Contemporary Artists Revisit Place, Race, and Memory* (organized by Tacoma Art Museum) and *Baja to Vancouver: The West Coast and Contemporary Art* (organized collaboratively by CCA Wattis Institute for Contemporary Arts, Museum of Contemporary Art San Diego, Seattle Art Museum, and Vancouver Art Gallery).

Brophy is currently represented by the Laura Russo Gallery in Portland and the Bryan Ohno Gallery in Seattle.

Select Bibliography

Abbott, Carl. *The Great Extravaganza: Portland and the Lewis and Clark Exposition.* Portland, Ore.: Oregon Historical Society, 1981.

———. *Greater Portland: Urban Life and Landscape in the Pacific Northwest.* Philadelphia: University of Pennsylvania Press, 2001.

Adamson, Thelma. *Folk-Tales of the Coast Salish,* vol. 27. New York: The American Folk-lore Society and G. E. Stechert and Co., Agents, 1934.

Alinder, James, ed. *Carleton E. Watkins: Photographs of the Columbia River and Oregon.* With essays by David Featherstone and Russ Anderson. Carmel, Calif.: The Friends of Photography, in association with the Weston Gallery, 1979.

Anderson, Nancy K. *Thomas Moran.* With contributions by Thomas P. Bruhn, Joni L. Kinsey, and Anne Morand. Washington, D. C.: National Gallery of Art; New Haven, Conn., and London: Yale University Press, 1997.

Anderson, Nancy K., and Linda S. Ferber. *Albert Bierstadt: Art & Enterprise.* New York: Hudson Hills Press, in association with the Brooklyn Museum, 1990.

Andrews, Ralph W. *Timber: Toil and Trouble in the Big Woods.* 2nd ed. Atglen, Penn.: Schiffer Publishing Ltd., 1984.

Atchison, Topeka, and Santa Fe Railway Company. *An Exhibition of Paintings of the Southwest from the Santa Fe Railway Collection* [S.l. : s.n. 1966].

Boas, Franz. *The Growth of Indian Mythologies: A Study Based upon the Growth of the Mythologies of the North Pacific Coast,* vol. 9. [Boston]: Journal of American Folklore, 1896.

Branch, Michael P., Rochelle Johnson, Daniel Patterson, and Scott Slovic, eds. *Reading the Earth: New Directions in the Study of Literature and the Environment.* Moscow, Idaho: University of Idaho Press, 1998.

Brown, David Blayney. *Romanticism.* London and New York: Phaidon Press, 2001.

Carbone, Teresa A. *Eastman Johnson: Painting America.* New York: Brooklyn Museum of Art, in association with Rizzoli, 1999.

Chittick, V. L. O., ed., *Northwest Harvest: A Regional Stocktaking.* New York: The Macmillan Company, 1948.

Conkelton, Sheryl, and Laura Landau. *Northwest Mythologies: The Interactions of Mark Tobey, Morris Graves, Kenneth Callahan, and Guy Anderson.* Tacoma, Wash.: Tacoma Art Museum, in association with University of Washington Press, Seattle, Wash., and London, 2003.

Cox, Thomas R. *Mills and Markets: A History of the Pacific Coast Lumber Industry to 1900.* Seattle: University of Washington Press, 1974.

Cronon, William. "Comments on 'Landscape History and Ecological Change.'" *Journal of Forest History* 33 (1989): 125–27.

Cronon, William, ed. *Uncommon Ground: Rethinking the Human Place in Nature.* New York and London: W. W. Norton & Company, 1996.

Cronon, William, Miles George, and Jay Gitlin. *Under an Open Sky: Rethinking America's Western Past.* New York and London: W. W. Norton & Company, 1992.

D'Ambrosio, Charles. *Michael Brophy: Paintings.* Astoria, Ore.: Clear Cut Press, 2003.

Davis, Charles, ed. *Western Public Lands and Environmental Politics.* Boulder, Colo.: Westview Press, 1997.

DeVuono, Frances. "Washington: Michael Brophy at Linda Hodges Gallery." *Artweek* 27 (July 1996): 28.

Dodds, Gordon B. *The American Northwest: A History of Oregon and Washington.* Arlington Heights, Ill.: The Forum Press, Inc., 1986.

Doig, Ivan, Rock Hushka, and Patricia McDonnell. *Building Tradition: Gifts in Honor of the Northwest Art Collection.* Tacoma, Wash.: Tacoma Art Museum, 2003.

Fedkiw, John, Douglas W. MacCleery, and V. Alaric Sample. *Pathway to Sustainability: Defining the Bounds on Forest Management.* Durham, N.C.: Forest History Society, 2004.

Ficken, Robert E. *The Forested Land: A History of Lumbering in Western Washington.* Seattle: University of Washington Press, 1987.

Flexner, James Thomas. *That Wilder Image: The Painting of America's Native School from Thomas Cole to Winslow Homer.* New York: Bonanza Books, 1962.

Floyd, Donald W. *Forest Sustainability: The History, the Challenge, the Promise.* Durham, N.C.: The Forest History Society, 2002.

Gragg, Randy. "Transcending Politics, Embracing Paradox." *Oregonian,* September 18, 1995, D5.

Gragg, Randy, and Matthew Stadler, eds. *Core Sample: Portland Art Now.* Astoria, Ore.: Clear Cut Press, 2004.

Grobnik, Slats. "Forgotten Foundations: Recent Paintings by Michael Brophy." *Plazm* 21 ([first quarter] 1999): 28–31.

Haak, Bob. *The Golden Age: Dutch Painters of the Seventeenth Century.* Translated and edited by Elizabeth Willems-Treeman. New York: Harry N. Abrams, with the cooperation of the Prince Bernhard Foundation, 1984.

Haskell, Barbara. *The American Century: Art & Culture 1900–1950.* New York: Whitney Museum of American Art, in association with W. W. Norton & Company, 1999.

Hays, Samuel P. *A History of Environmental Politics since 1945.* Pittsburgh, Pa.: University of Pittsburgh Press, 2000.

Hirt, Paul W. *A Conspiracy of Optimism: Management of the National Forests since World War Two.* Lincoln, Neb.: University of Nebraska Press, 1994.

Johansen, Dorothy O. "Oregon's Role in American History: An Old Theme Recast." *Pacific Northwest Quarterly* 38 (April 1949): 85–92.

Johnson, Deborah J. *William Sidney Mount: Painter of American Life.* New York: American Federation of Arts, 1998.

Judd, Richard W., and Christopher S. Beach. *Natural States: The Environmental Imagination in Maine, Oregon, and the Nation.* Washington, D.C.: Resources for the Future, 2003.

Kangas, Matthew. "Seattle: Michael Brophy at Linda Hodges." *Art in America* 85 (February 1997): 110.

Kelly, Franklin. *Frederic Edwin Church.* With contributions by Stephen Jay Gould, James Anthony Ryan, and Debora Rindge. Washington, D.C.: National Gallery of Art, 1989.

Kemp, J. Larry. *Epitaph for the Giants: The Story of the Tillamook Burn.* Portland, Ore.: Touchstone Press, 1967.

Kempton, Willett, James S. Boster, and Jennifer A. Hartley. *Environmental Values in American Culture.* Cambridge, Mass., and London: The MIT Press, 1995.

Koerner, Joseph Leo. *Caspar David Friedrich and the Subject of Landscape.* New Haven, Conn., and London: Yale University Press, 1990.

Kornhauser, Elizabeth Mankin. *Marsden Hartley,* with contributions by Ulrich Birkmaier, Donna M. Cassidy, Wanda M. Corn, Amy Ellis, Randall R. Griffey, Stephen Kornhauser, Townsend Ludington, Patricia McDonnell, Bruce Robertson, Carol Troyen, and Jonathan Weinberg. Hartford, Conn.: Wadsworth Atheneum Museum of Art, in association with Yale University Press, 2002.

Lang, William L. "Beavers, Firs, Salmon, and Falling Water: Pacific Northwest Regionalism and the Environment." *Oregon Historical Quarterly* 104 (Summer 2003): 151–65.

Langston, Nancy. *Forest Dreams, Forest Nightmares: The Paradox of Old Growth in the Inland West.* Seattle: University of Washington Press, 1995.

Maciejunes, Nannette V., Michael D. Hall, and Charles Ephraim Burchfield. *The Paintings of Charles Burchfield: North by Midwest.* New York: Harry N. Abrams, in association with the Columbus Museum of Art, 1997.

Mackie, Richard. *Trading beyond the Mountains: The British Fur Trade on the Pacific, 1793–1843.* Vancouver, B.C.: UBC Press, 1997.

Maddox, Kenneth W. *In Search of the Picturesque: Nineteenth Century [sic] Images of Industry along the Hudson River Valley.* Catalogue essay by Kenneth W. Maddox; contemporary site photography by Douglas Baz. Annandale-on-Hudson, N.Y.: Bard College, 1983.

Marx, Leo. *The Machine in the Garden: Technology and the Pastoral Ideal in America.* 35th anniversary ed. Oxford, Eng., and New York: Oxford University Press, 2000.

Merk, Frederick. *Manifest Destiny and Mission in American History: A Reinterpretation.* Rev. ed. Cambridge, Mass.: Harvard University Press, 1987.

Murdoch, David Hamilton. *The American West: The Invention of a Myth.* Reno, Nev., and Las Vegas, Nev.: University of Nevada Press, 1988.

National Collection of Fine Arts, Smithsonian Institution. *Art of the Pacific Northwest from the 1930s to the Present.* Washington, D.C.: Smithsonian Institution Press, 1974.

Nickel, Douglas R. *Carleton Watkins: The Art of Perception.* San Francisco: San Francisco Museum of Modern Art, 1999.

Novak, Barbara. *American Painting of the Nineteenth Century: Realism, Idealism, and the American Experience.* 2nd ed. New York: Harper & Row, Icon Editions, 1979.

O'Connor, Francis, ed. *Art for the Millions: Essays from the 1930s by Artists and Administrators of the WPA Federal Art Project.* Boston: New York Graphic Society, 1973.

Ott, Jennifer. "'Ruining' the Rivers in the Snake Country: The Hudson's Bay Company's Fur Desert Policy." *Oregon Historical Quarterly* 104 (Summer 2003): 166–95.

Phillips, Sandra S., Richard Rodriguez, Aaron Betsky, and Eldridge M. Moores. *Crossing the Frontier: Photographs of the Developing West, 1849 to the Present*. San Francisco: San Francisco Museum of Modern Art and Chronicle Books, 1996.

Portland Art Museum. *Portland Art Museum: Selected Works*. Portland, Ore.: Portland Art Museum, 1996.

Prown, Jules David. *Discovered Lands, Invented Pasts: Transforming Visions of the American West*. With contributions by Nancy K. Anderson, William Cronon, Brian Dippie, Martha A. Sandweiss, Susan Prendergast Schoelwer, and Howard Lamar. New Haven, Conn., and London: Yale University Press, 1992.

Raban, Jonathan. "Battleground of the Eye." *The Atlantic Monthly* 287 (March 2001): 40–52.

Rash, Nancy. *The Painting and Politics of George Caleb Bingham*. New Haven, Conn.: Yale University Press, 1991.

Raymond, Jonathan. "Forest Flaneur." *Anodyne* (August 1997): 34.

Robbins, William G. *American Forestry: A History of National, State, and Private Cooperation*. Lincoln, Neb.: University of Nebraska Press, 1985.

———. *Landscapes of Promise: The Oregon Story 1800–1940*. Seattle and London: University of Washington Press, 1997.

Robbins, William G., Robert J. Frank, and Richard E. Ross, eds. *Regionalism and the Pacific Northwest*. Corvallis, Ore.: Oregon State University Press, 1983.

Rodgers, David. "The Sublime," in *The Dictionary of Art*. Edited by Jane Turner, vol. 29. London: Grove, 1996: 889–91.

Rosenblum, Robert. *Modern Painting and the Northern Romantic Tradition: Friedrich to Rothko*. New York: Harper & Row, 1975.

Row, D. K. "Brophy on Brophy." *Oregonian*, August 21, 1999, E1.

Rugoff, Ralph, ed. *Baja to Vancouver: The West Coast and Contemporary Art*. San Francisco: CCA Wattis Institute for Contemporary Arts, 2003.

Russell, H. Diane. *Claude Lorrain: 1600–1682*. New York: George Braziller, in association with the National Gallery of Art, 1982.

Sandweiss, Martha A. *Print the Legend: Photography and the American West*. New Haven, Conn., and London: Yale University Press, 2002.

Schama, Simon. *Landscape and Memory*. New York: Vintage Books, 1995.

Schmied, Wieland. *Caspar David Friedrich*. Translated by Russell Stockman. New York: Harry N. Abrams, 1995.

Shapiro, Michael Edward. *George Caleb Bingham*. [St. Louis, Mo.]: Saint Louis Art Museum, in association with Harry N. Abrams, 1990.

Snyder, Eugene E. *Early Portland: Stump-Town Triumphant: Rival Townsites on the Willamette, 1831–1854*. 2nd ed. Portland, Ore.: Binford & Mort, 1984.

Soby, James Thrall, and Dorothy C. Miller. *Romantic Painting in America*. New York: The Museum of Modern Art, 1943.

Truettner, William H., ed. *The West as America: Reinterpreting Images of the Frontier, 1820–1920*. Washington, D.C., and London: National Museum of American Art, in association with the Smithsonian Institution Press, 1991.

Truettner, William H., and Alexander Nemerov. "What You See Is Not Necessarily What You Get: New Meaning in Images of the Old West." *Montana, the Magazine of Western History* 42 (Summer 1992): 70–76.

Truettner, William H., and Alan Wallach, eds. *Thomas Cole: Landscape into History*. New Haven, Conn.: Yale University Press; Washington, D.C.: National Museum of American Art, Smithsonian Institution, 1994.

Turney, Ida Virginia. *Paul Bunyan Comes West*. With illustrations by Helen Rhodes. Boston and New York: Houghton Mifflin Company; Cambridge, Mass.: The Riverside Press, 1928.

Wells, Gail. *The Tillamook: A Created Forest Comes of Age*. Corvallis, Ore.: Oregon State University Press, 1999.

White, Richard. "Environmental History, Ecology, and Meaning." *Journal of American History* 76 (March 1990): 1111–17.

———. *"It's Your Misfortune and None of My Own": A History of the American West*. Norman, Okla.: University of Oklahoma Press, 1991.

———. *The Organic Machine*. New York: Hill and Wang, 1995.

Wolf, Bryan Jay. *Romantic Re-Vision: Culture and Consciousness in Nineteenth-Century American Painting and Literature*. Chicago and London: University of Chicago Press, 1982.

World Commission on Environment and Development. *Our Common Future: The World Commission on Environment and Development*. Oxford, Eng., and New York: Oxford University Press, 1987.

Works in the Exhibition

All dimensions are listed with height preceding width.

Paintings by Michael Brophy

Small Fish, 1991
Oil on canvas
59 × 35 inches
Collection of Tonkon Torp, LLP,
Law Firm

Fall, 1993
Oil on canvas
60 × 54 inches
Microsoft Art Collection

Key, 1994
Oil on canvas
71 × 66 inches
Collection of the artist, Courtesy
of Laura Russo Gallery, Portland

Couple, 1995
Oil on canvas
65 × 70 inches
Collection of the artist, Courtesy
of Laura Russo Gallery, Portland

Fire, 1995
Oil on canvas
65 × 70 inches
Oregon State University Libraries,
Corvallis, Oregon

By Moonlight, 1996
Oil on canvas
40 × 39¾ inches
Washington State Art Collection in
partnership with Tonasket School
District

View, 1996
Oil on canvas
89 × 95 inches
Bell Family Collection

January, 1997
Oil on canvas
78 × 96 inches
Tacoma Art Museum, Museum
purchase with funds from the
Dr. Lester Baskin Memorial Fund

Portrait, 1997
Oil on canvas
96 × 60 inches
Private collection

Snag I, 1997
Oil on canvas
91 × 60 inches
Tacoma Art Museum, Gift of the
artist and Laura Russo Gallery,
Portland

Snag II, 1998
Oil on canvas
95 × 54 inches
Collection of Arlene and
Harold Schnitzer

Survey, 1998
Oil on canvas
79 × 85 inches
Private collection

Gorge, 1999
Oil on canvas
78 × 84 inches
Collection of Mr. and
Mrs. David Roche

People's View, 1999
Oil on canvas
78 × 96 inches
Private collection

Small Curtain, 1999
Oil on canvas
49 × 37 inches
Safeco Art Collection

Air, Earth, Fire, and *Water*, 2000
(polyptych)
Oil on canvas
16¼ × 13½ inches each
Collection of Arlene and
Harold Schnitzer

Measure, 2000
Oil on canvas
84 × 78 inches
Reed College Art Collection,
Reed College

*Twilight of the Beaver Trade,
Stark's Claim,* and *Pastures of
Plenty*, 2000 (triptych)
Oil on canvas
19½ × 17 inches each
Private collection

Burnt Casing, 2001
Oil on canvas
61 × 49 inches
Private collection

Columbia River Jargon, 2001
Gouache on paper
7½ × 5 inches each
Miller Meigs Collection, Corvallis,
Oregon
a. *Range*
b. *Portrait*
c. *Run*
d. *Canoe*
e. *Clippership*
f. *Label*
g. *Pelt*
h. *Trade Tower*
i. *Father John*
j. *Smallpox*
k. *Malaria*
l. *Claim*
m. *The Happy Merchant*

n. *Steam and Navigation*
o. *Springboard*
p. *Benson Raft*
q. *Fish Wheel*
r. *Channel*
s. *BPA*
t. *Dam*
u. *Power Grid*
v. *Fatigue*
w. *The Stump Curtain*
x. *Overflow*
y. *The Spiritual Moment*
z. *City Coat*

Beaver Trade, 2002
Oil on canvas
78 × 84 inches
Collection of the artist, Courtesy of
Laura Russo Gallery, Portland

Heart of the Cascades, 2002
Oil on canvas
78 × 96 inches
Collection of the artist, Courtesy of
Laura Russo Gallery, Portland

National Recreation Area, 2002
Oil on canvas
80 × 90 inches
Collection of the artist, Courtesy of
Laura Russo Gallery, Portland

Old Growth, 2002
Oil on canvas
74 × 94 inches
Collection of the artist, Courtesy of
Laura Russo Gallery, Portland

The Royal Court, 2003–04 (triptych)
Oil on canvas
91 × 260 inches overall
Collection of the artist, Courtesy of
Laura Russo Gallery, Portland

Hallic Ford Museum of Art Staff

John Olbrantz, The Maribeth Collins Director

Mike Castellanos, Custodian
Elizabeth Ebeling, Front Desk Receptionist
Elizabeth Garrison, The Cameron Paulin Curator of Education
Carolyn Harcourt, Administrative Assistant
Keith Lachowicz, Exhibition Designer / Chief Preparator
Mary Parks, Curator of Collections
Frank Simons, Safety Officer
Christine Zollner, Front Desk Receptionist

Tacoma Art Museum Staff

Rod A. Bigelow, Interim Executive Director/Chief Financial Officer

Margaret Bacon, Visitor Services Representative

Jessica Balsam, Development Coordinator

Derrek Bull, Security Officer

Brian Burke, Visitor Services Representative

Carri Campbell, Assistant Curator of Education

Courtenay Chamberlin, Director of Community Relations

Irene Conley, Security Officer

Zoe Donnell, Curatorial Assistant

Beth Doty, Visitor Services Representative

Shannon Eakins, School Tour Instructor/Volunteer Coordinator

Jared Flood, Visitor Services Representative

Marge Gillies, Store Associate

Kristy Gledhill, Director of Communications

Kevin Guenzi, Executive Assistant

Jacqueline Harmon, Education Assistant

Al Haskins, Facilities Manager

Janae C. Huber, Registrar

Rock Hushka, Curator

Sara Inveen, Associate Director of Development

JaPonica Johnson, Visitor Services Representative

Jeanette Jones, Manager, Special Events

Robert Kane, Visitor Services Representative

Leslie Martin Kinkade, Director of Development

Michael Lent, Membership Administrator

Paula McArdle, Curator of Education

Patricia McDonnell, Chief Curator

Maija McKnight, Community Programs Coordinator

Gina Mercer, Visitor Services Representative

Andy Morrison, Visitor Services Lead

Leslie Patton, Accounting Associate

Allison Peake, Manager, Foundation and Corporate Relations

Chelsea Perry, Public Relations Assistant

Emily Shirbroun, Exhibition and Collection Assistant

Jessica Thompson, Visitor Services Representative

Nancy Thompson, Store Manager/Buyer

Rose vanOmmen, Food Service Manager

Vince Warner, Head Preparator

Jana Wennstrom, Store Associate

Sharon Winters, Resource Center Coordinator

Kristie Worthey, Visitor Services Representative

Published in conjunction with *The Romantic Vision of Michael Brophy*, a collaborative project of Tacoma Art Museum and Hallie Ford Museum of Art, Willamette University. At Tacoma Art Museum, it takes part in the *Northwest Perspective Series* of one-person exhibitions devoted to artists of the region. The exhibition appears from June 4 through August 27, 2005, in Salem, and from October 8, 2005, through January 1, 2006, in Tacoma.

This publication is made possible through the cooperation of the Hallie Ford Museum of Art, Willamette University, Salem, Oregon; the Laura Russo Gallery, Portland, Oregon; Michael Brophy; and Tacoma Art Museum.

Library of Congress Control Number: 2005922787
ISBN: 0-295-98528-3

Tacoma Art Museum
1701 Pacific Avenue
Tacoma, Washington 98402

Distributed by
University of Washington Press
P.O. Box 50096
Seattle, Washington 98145-5096
www.washington.edu/uwpress

Content editor: Jana Stone
Proofreader: Sharon Rose Vonasch
Designer: John Hubbard
Book production: Marquand Books, Inc., Seattle
 www.marquand.com
Color separator: iocolor, Seattle
Printed and bound in China by C&C Offset Printing Co., Ltd.

All reproductions of artwork by Michael Brophy appear courtesy of the artist.

Kenneth Callahan, *Cascades*, appears courtesy of the Kenneth Callahan Estate.

The following photographic images are reproduced courtesy of:

Page 22, William Kurtz: National Gallery of Art Library, Washington, D.C.

Page 47, Carleton Watkins: Oregon Historical Society, #OrHi21590, #OrHi21589, #OrHi21588

Page 60, Caspar David Friedrich: Bildarchiv Preussischer Kulturbesitz / Art Resource, New York

All photographs of artwork are by Bill Bachhuber except the following:

Pages 2, 5, 8, 15, 31, 33, 55, and 59: Richard Nicol

Pages 3 and 57: Terry Mills

Page 22: National Gallery of Art Library, Washington, D.C.

Page 28: Aaron Johanson

Page 30: Stephen Meyer

Page 47 (top): Oregon Historical Society

Page 47 (bottom): Mark Stephenson

Page 52: Vanessa Renwick

Page 60: Elke Walford

Front cover: Michael Brophy, *Water*, 2000 (polyptych, detail, see Fig. 32.3)

Back cover: Michael Brophy, *National Recreation Area*, 2002 (detail, see Fig. 34)

Page 2: Michael Brophy, *Fall*, 1993 (detail, see Fig. 30)

Page 3: Michael Brophy, *By Moonlight*, 1996 (detail, see Fig. 28)

Page 5: Michael Brophy, *Small Curtain*, 1999 (detail, see Fig. 15)

Page 8: Michael Brophy, *View*, 1996 (detail, see Fig. 27)